multi-cultural
CELEBRATIONS

the paintings of
BETTY LA DUKE
1972–1992

by **GLORIA FEMAN ORENSTEIN**

with a preface by **BRUCE GUENTHER**

POMEGRANATE ARTBOOKS san francisco

Published by Pomegranate Artbooks
Box 6099, Rohnert Park, CA 94927

Text © 1993 Gloria Feman Orenstein
Paintings © 1993 Betty LaDuke
Photographs of paintings by Robert Jaffe, Ashland, Oregon

Hardcover ISBN 1-56640-600-5
Paperback ISBN 1-56640-452-5
Library of Congress Catalog Card Number 92-62861

Front cover: *Africa: Millet Rhythms*, 1992, acrylic, 72 x 68 in.

Designed by Bonnie Smetts Design

Printed in Korea

contents

The Author **ii**

A Dance with Life *by Bruce Guenther* **iii**

Introduction **v**

1 Dreams and Creation Myths **2**

2 Birth and Nurturing **14**

3 Children: Being and Becoming **30**

4 Courtship and Marriage **48**

5 Earth Survival **68**

6 Markets: Change and Interchange **84**

7 Sacred Sites, Shrines, and Temples **96**

8 Healers **110**

9 Pilgrimages and Processions **120**

10 Death and the Spirit's Journey **132**

the author

Gloria Feman Orenstein is professor of comparative literature and of the program for the study of women and men in society at the University of Southern California. She is author of *The Theatre of the Marvelous; Surrealism and the Contemporary Stage* and *The Reflowering of the Goddess,* and she is coeditor of *Reweaving the World: The Emergence of Ecofeminism.* Orenstein has studied with a shaman from the arctic circle and was cocreator of The Woman's Salon for Literature in New York City.

a dance with life

The invitation to write a preface for this book has set me adrift on a sea of retrospection that reaches well back over a quarter of a century, to my first introduction as an undergraduate advisee to Betty LaDuke and her art. I find in the life and work of this activist artist the beginnings of my own life journey as well as a mirror of changes that have coursed across our nation in that time. I am thus challenged anew to confront questions about and struggle with issues of marginalization, Western hegemonic art, and cultural authenticity.

Betty LaDuke has sought to attain a convergence of the personal and the political in her paintings and prints. In this search she has held true to the vision and aesthetics of her earliest teachers, Elizabeth Catlett and Charles White—two of the United States's great African-American artists. Later LaDuke's mentor was the master draftsperson Rico Lebrun; her exemplars came from the work of the Mexican muralist movement.

Events of the 1960s—the years of the American civil rights struggle, the Vietnam antiwar movement, and the nascent women's movement—were reflected in LaDuke's quest to develop an imagery of engagement that expressed formally as well as emotionally the intensity of her commitment. The rapid, slashing brushwork and often clotted, visceral surfaces of the artist's paintings at this time eloquently conveyed the intensity of feeling that brought the contorted birds, animals, and human figures of these canvases into being. The rough, deeply bitten and embossed intaglio prints of this period, with their limited color, saturated blacks, and cutout shapes, mirrored the shattering of complacent, white bourgeois society as we had known it. The strong, simple silhouettes of her figures against a plain field, combined with the vigorous handling of materials, communicated LaDuke's deeply felt humanism and represented an important step in her integration of content and formal devices. As an artist and a teacher in the 1960s, LaDuke spoke out against purely formal art-about-art, arguing instead for a narrative art of social engagement.

With the end of the Vietnam War and the birth of her son Jason in the early 1970s, LaDuke left behind the disquiet of the tumultuous 1960s, with her personal struggles and formal experimentation.

She turned her energies to the creation of paintings and prints that expressed her deepening sense of womanhood and the stability of her family. The surfaces became smoother and more integrated, and her palette brightened and expanded. No longer dominated by blood reds and inky blacks, the canvases came alive with yellows, pinks, greens, and blues that conveyed hope and love. The figures that populated her work at this time also became smoother, less jagged and fractured, more sensuous.

In 1972 LaDuke embarked on her first journey to India, where she confronted afresh the seemingly contradictory vigor of an artisanal popular culture. It ran counter to the constrained Western beaux-arts tradition—a contradiction she had first experienced some twenty years earlier as a young woman in Mexico. The Western concept of cultural divisions between high and low, ancient and recent, was once more subject to her questioning. LaDuke then began to move easily toward integration of folkloric form and pattern into the formal vocabulary of her work. She began to overlay mythology on the domestic narratives that emerged in her work in the early 1970s. Invigorated and challenged by her experiences in India, subsequently Betty LaDuke has spent the last twenty years exploring the non-Western world.

A firsthand witness to the cultural decentralization of the contemporary art dialogue, LaDuke, in her sketchbook tours and subsequent publications, has gathered preliminary data on women artists and women's lives from different geographical and political contexts. This volume presents the paintings and prints that have evolved from those travels. They embody the artist's continuing effort to give voice to the emotional reality of her family, women's spiritual identity, and humanity's relationship to the Earth. The bold simplicity of LaDuke's imagery with its totemic personages, stylized patterning, and rich coloration belies the often-complex overlays and cross-referencing of cultural and mythic and spiritual symbolism she constructs for her canvases.

Seeking in the lives and art of non-Western women a mirror of her own experiences and symbols for a larger, universal truth, Betty LaDuke remains true to the heritage and spirit of the socially engaged artist. Her focus on personal growth and self-definition in the 1970s and her celebration of cultural diversity in the 1980s and 1990s has kept her work vibrant and urgently current.

Bruce Guenther
Newport Harbor, California
February 1993

introduction

As we approach the end of the millennium, both physicists and metaphysicians are predicting a paradigm shift that will inaugurate a new age. Some descriptions of our evolution as a global civilization include epithets such as "holistic," "multi-cultural," "ecological," "feminine," and "spiritual," and concepts such as the decentering of white, Anglo-European values; the eclipse of patriarchy; and a reintegration of science and spirituality within a new cosmic vision.

Artists as visionaries in their own time can often give us a glimpse of the changes in perception and consciousness that await us via their imaginative, creative journeys, both inward and outward, across space and time.

If there is any one twentieth-century artist whose work is prophetic of the shift in values that we will experience in the twenty-first century, it is Betty LaDuke.

JOURNEYS

Betty LaDuke's parents were immigrants who came to the Bronx from Russia and Poland. They had lived in villages straight out of Chagall paintings. Her father was a house painter, her mother a seamstress in a pocketbook factory. It is from her parents that Betty LaDuke inherited a deep respect for people everywhere who work with their hands and actively struggle to protect human rights.

LaDuke, born in 1933, was an only child. Her summers were partially spent at a summer camp at which the art directors were African-American artists Charles White and Elizabeth Catlett. They encouraged Betty's art and taught her many important values related to dignity, strength, and cultural diversity. Later, attending New York City's High School of Music and Art in Harlem, LaDuke began to explore the city's ethnic neighborhoods, sketchbook in hand.

Her nomadic journeys began during the summer of 1951, when she left Denver University, which she had attended on a scholarship, and took her sketchbook, a small suitcase, and seventeen dollars she had saved from a waitress job and hitchhiked south. She went down the Mississippi River on a

small riverboat that tugged barges from Kansas City, Missouri, to Cairo, Illinois. From Cairo she hitched to Memphis, where for a few days she hoed weeds in the cotton fields. Finally she arrived in New Orleans, where she worked as a waitress and spent her free time listening to jazz and the blues.

In 1953, for her third year of college, LaDuke was awarded a scholarship to attend the Instituto Allende in San Miguel de Allende, Mexico. Although her scholarship was renewed, her ambition was to continue painting on her own. So in 1954 she moved to Guanajuato, where she lived on a small grant and began the life apprenticeship that would ultimately culminate in the works in this book. Each day she visited the marketplaces and attended the traditional celebrations, sketching as she went. During the next two years she had five one-person, government-sponsored shows. She was considered by the critics who reviewed her shows to be one of Mexico's "new generation" of artists.

However, Betty LaDuke's art work has always been more intimately involved with her larger quest than with seeking fame. Thus, having read a book about the Otomi Indians' cultural survival, she embarked upon a new adventure and went to live among the Otomi Indians in Mexico. She presented photographs of her paintings and recent exhibitions along with reviews of her work to the Patrimonio Indigenista del Valle de Masquital (P.I.V.M.), a government and United Nations organization, and obtained a job as a mural painter for the patio walls of one-room schoolhouses in the villages of San Juanico, Ojai, and Patria Nueva. In each village she stayed with and met families and continued her sketching and painting. During this year LaDuke witnessed many rites of passage: births, deaths, and saints' days celebrations. What she learned from her life among the Otomis, who had managed to preserve their cultural heritage despite government efforts to mainstream them, was a lasting lesson about indigenous peoples' strength and endurance.

In 1956, after returning from Mexico to New York City, LaDuke supported herself by teaching art in various community centers. In 1957 she was director of the art program at the Grand Street Settlement House. After meeting Sunbear (Vincent LaDuke), the pair moved to Los Angeles. There he worked as a screen extra, portraying Hollywood's version of Indian life, and Betty earned her master of arts degree at California State University, Los Angeles. Their daughter, Winona LaDuke, was born in 1960.

After teaching art at Stevenson Junior High in East Los Angeles for three and one-half years, Betty

and Sunbear parted, and Betty and Winona moved to Ashland, Oregon. There Betty established her career in the art department of Southern Oregon State College. A year later, in 1965, Betty married Peter Westigard, an agricultural scientist. While raising Winona and their son Jason, born in 1970, Betty began her annual worldwide travels. In 1972, thanks to Peter's support and encouragement as well as her first sabbatical from teaching, she made her first of many trips abroad, traveling alone to India. Though LaDuke is also a printmaker in the etching or intaglio media, this select collection of images focuses primarily on LaDuke's multi-cultural paintings from India, 1972, to Africa, 1992.

ARTIST-STORYTELLER

Each summer Betty LaDuke would set off with camera and sketchbook and journey for four to six weeks in pursuit of knowledge about non-Western countries and women artists, both known and unknown. LaDuke's travels include: Asia, between 1972 and 1978—India, the People's Republic of China, and Indonesia; Oceania, between 1978 and 1980—Papua New Guinea, Australia, and Borneo; Latin America, between 1981 and 1985—Chile, Nicaragua, Bolivia, Peru, Brazil, Mexico, Guatemala, Honduras, Cuba, Haiti, Grenada, the San Blas Islands, Ecuador, and Puerto Rico; and Africa between 1985 and 1992—Nigeria, the Ivory Coast, Cameroon, Ghana, Senegal, Mali, Egypt, Morocco, Togo, and Benin.

When she returned home, she began the difficult but joyful work of writing books documenting the lives and art of the women she had interviewed, and of creating her own art, which as always was inspired by her experiences during her journeys. The books she has written about these women artists, who are both well-known painters and sculptors and village artisans, are: *Compañeras: Women, Art, and Social Change in Latin America* (San Francisco: City Lights, 1985); *Africa: Through the Eyes of Women Artists* (Trenton, New Jersey: Africa World Press, 1991); and *Women Artists: Multi-Cultural Visions* (Trenton, New Jersey: Red Sea Press, 1992).

At Southern Oregon State College, in addition to teaching studio art, LaDuke initiated the courses "Women and Art" and "Art in the Third World." Observing the multi-cultural diversity of art by women worldwide, LaDuke recognized that, among most indigenous peoples, the aesthetic values of art were

organically connected to its utilitarian and spiritual functions. Moreover, non-Western women who make art do not reduce their personal identities to just one activity. They are simultaneously artists, agricultural workers, political activists, and carriers of the traditions of their cultures. They are the storytellers of their communities.

Like these women who inspire her, Betty LaDuke also considers herself to be an artist/storyteller/activist. Indeed, when I visited her in June 1992, Betty mentioned that she had just finished reading *The Storyteller* by Mario Vargas Llosa and that certain passages in his book explain how she identifies herself at the deepest, core level of her being.

Vargas Llosa writes: "Talking the way a storyteller talks means being able to feel and live in the very heart of that culture, means having penetrated its essence, reached the marrow of its history and mythology, given body to its taboos, images, ancestral desires, and terrors." *

In contrast to artists who journey around the world in search of exotic, ethnic art objects, either for their collections or as models for their creative work, Betty LaDuke has never traveled as a "tourist." Instead, she has always opened herself to living in the culture she is visiting. She wants to learn to see things through the eyes of the indigenous people as well as through her own, and for that reason she typically stays in countries for a month or more at a time. I traveled a bit with Betty when we both attended a feminist conference in Yugoslavia (which was where we met), and I can attest to the fact that her mode of travel is not touristic, not at all. Contrary to the way westerners who reside abroad often preach about the advantages of American life and values (missionary mode), Betty LaDuke returns to the U.S. to tell us about what we have lost since we left a life wedded to the land and the spirit world for the so-called "advantages" of modern technological culture.

This, then, is her story, and as a storyteller she wants to transmit to us, as Vargas Llosa has expressed it, "the marrow of its history and mythology."

In the works presented here, LaDuke has become a storyteller in at least three ways; in her art these three threads are interwoven. First, she tells us stories about the countries she has visited, the history, the mythology, the customs, and the role of women and artists in those cultures. What she finds most

* Vargas Llosa, Mario, *The Storyteller*. New York: Penguin Books, 1990, p. 241.

inspiring is that many women artists across the continents have been resistance fighters in the war against colonialism and oppression.

Second, LaDuke is also the storyteller of the spiritual and ecological values and practices of indigenous peoples around the world. Here she becomes an ecofeminist in her own art as well, for she shows us the interconnectedness of all things visible and invisible and of all species within the great source of being, the Mother Goddess, who symbolizes the Earth. These are the holistic values that are inspired by her revisiting native cultures that still live in harmony with nature and in communication with the spirit world.

Third, Betty LaDuke incarnates the role of the storyteller in our culture as she both writes and paints the stories of women artists and indigenous peoples from all over the globe in her books and in her art in order to awaken us in the West to our own political, spiritual, and ecological plight. Characteristic of the stories told by traditional tellers of tales is the way in which a multitude of story variants are spontaneously invented for a core set of characters and actions.

In these ten chapters, divided into themes, we see how the artist has spun numerous variants on the motifs that she identifies as having common threads cross-culturally. They may be woven on disparate looms and rendered in different hues, each according to specific cultural traditions, but creation myths, birth, courtship, Earth survival, healing, death, and so on, are themes that bridge what otherwise might prove to be insurmountable political and cultural differences—gaps that divide women, and indeed all peoples, from each other.

If we look at these topics as sites of sisterhood, brotherhood, and sharing, we recognize that in the West we have undervalued many of the important concerns that are given priority in other cultures, such as the spirit's journey, visits to sacred sites, the survival of the Earth, and dreams and creation myths. Thus, not only does LaDuke's oeuvre celebrate the multi-cultural diversity of women's, men's, and children's lives and common experiences, but it also implies a profound critique of the ideological foundations of Western civilization since the Enlightenment, which has severed us from those traditions that gave priority to our spiritual journey and to our interconnectedness with other species and cultures.

Betty LaDuke's art makes visible to westerners what is and has been obvious to other peoples of the

Earth from time immemorial—the fact that we are one, that we are interconnected in the sense that we flow through each other's bodies, minds, and cultures in a constant dance of life. This important visual oeuvre also explodes all stereotypes anyone could have constructed concerning the adjective "feminine." "The feminine" is here shown to be variegated and to consist of images of women observed in a wide range of roles from resistance fighters to healers, from agricultural workers to tradeswomen, from mothers and daughters to ritualists, from political activists to wives, from nomads to storytellers, from artists to spiritual pilgrims, from dreamers to awakeners. In all of these diverse roles, however, there is one constant definition of female energy that runs throughout the myriad forms of the manifestation of "the feminine" in our world as LaDuke sees it, and that is the fact that women have the power to determine the quality of life for future generations. Thus the responsibility exercised by women in positions of power (as healers of body and soul, as tradespeople, as workers and tenders of the Earth, as bearers and transmitters of their traditions) demonstrates their high level of commitment to values that insist upon the fact that we must not rob the future for the sake of the present.

Because Betty LaDuke's definition of an artist is not simply that of a creator of art objects, but of a person whose entire life fabric is woven so as to create a multi-dimensional artistic statement, she is able to see the connections between the creativity in people's personal and political lives as well as in their aesthetic creations. There are, for LaDuke, reciprocally empowering and socially responsible elements both in people's life works and in their art works. LaDuke's art awakens us from our eco-amnesiac slumber and calls us back to our responsibility as both guardians and creators of a healthy, sane, and wise civilization for our planet.

We frequently find the hands of women in LaDuke's work either holding a bird or being transformed into birds. This leitmotif has become a hallmark of her style and an important symbol of the message that she brings us as the carrier of knowledge she has retrieved on her nomadic, quasi-shamanic voyages. Women around the world, she has observed, are employing the skills and talents of their hands in the performance of acts of labor, love, and creation in order to bring forth a spiritual transformation in which peace (the dove) will be restored, and so that the soul will return to our civilization in the nearest possible future. Women's arms—as birds and bird-bearers—stretch far into the

universe and into the vast expanses of timeless time, as they bring spirit down to Earth and reach up to the stars to embrace and embody their dreams of peace.

Betty LaDuke has dedicated her book *Africa: Through the Eyes of Women Artists* to the late artists June Beer, Inji Efflatoun, and Edna Manley, from Nicaragua, Egypt, and Jamaica, who remain with us in spirit. She has dedicated her book *Women Artists: Multi-Cultural Visions* to her first art teachers and artist friends, Charles White and Elizabeth Catlett. From her dedications we can experience the hands of the artist Betty LaDuke reaching back into her past to thank her first art teachers and out into the unknown dimensions of the spirit world to thank those artist/activists who are no longer with us. Here we see the artist making the gesture she has so often painted, that of the hands reaching out from the past to the future, releasing the spirit dove of gratitude, as if she were placing a seed of rebirth in the universe to honor the values represented by these inspiring lives.

As the dove flies out of the women's (artists') hands, a spirit soars throughout creation, making the artist's work a vital link between tradition and transformation. It marks the turning point between despair and hope, identifying this body of art as a vision that provides us with one of the missing links for the renaissance of a rich, multi-cultural civilization on our planet.

multi-cultural CELEBRATIONS

1 dreams and creation myths

As contemporary women artists reclaim goddess symbolism today, they are envisaging creation in all its aspects (cosmic creation, procreation, and artistic creation) in the image of a female. As we travel with Betty LaDuke via this book to Latin America, Africa, Asia, and home, our spirits will be enlivened by the dance of creation as manifested by a female creator, who also participates in the "activities of evolution, preservation, destruction, embodiment, illusion, salvation, and grace."*

Because the female creator's dance is enacted within a sacred circle in which the beginning joins the end and the energy spirals round continually, we should connect this initial image, *Creation Dance*, with the final work presented in the book, *Tomorrow, Homage to Edna Manley*. Manley, a sculptor who died in her late eighties and became known as "the mother of modern Jamaican art," was also a political artist/activist whose works expressed the struggles of women, workers and indigenous Jamaican artists. An overview of LaDuke's art reveals a similarity of vision with the oeuvre of Edna Manley. Both artists celebrate the energies of creativity in all phases of the life cycle and all aspects of the great chain of being. Both artists make strong political statements protesting tyranny and violence, and despite the realism with which they confront political oppression they lend their spiritual gifts to the creation of works that incarnate a message of hope. It is the eternal cosmic energy generated by the *Creation Dance* that sustains Betty LaDuke's hopeful vision for *Tomorrow*, which stands at the end of this book as the hallmark of a new beginning, one in which art and politics, spirit and matter, male and female will be organically linked in a new creative harmony.

* Coomaraswamy, Ananda K. *The Dance of Shiva*. New York: Noonday Press, n.d., p. 70.

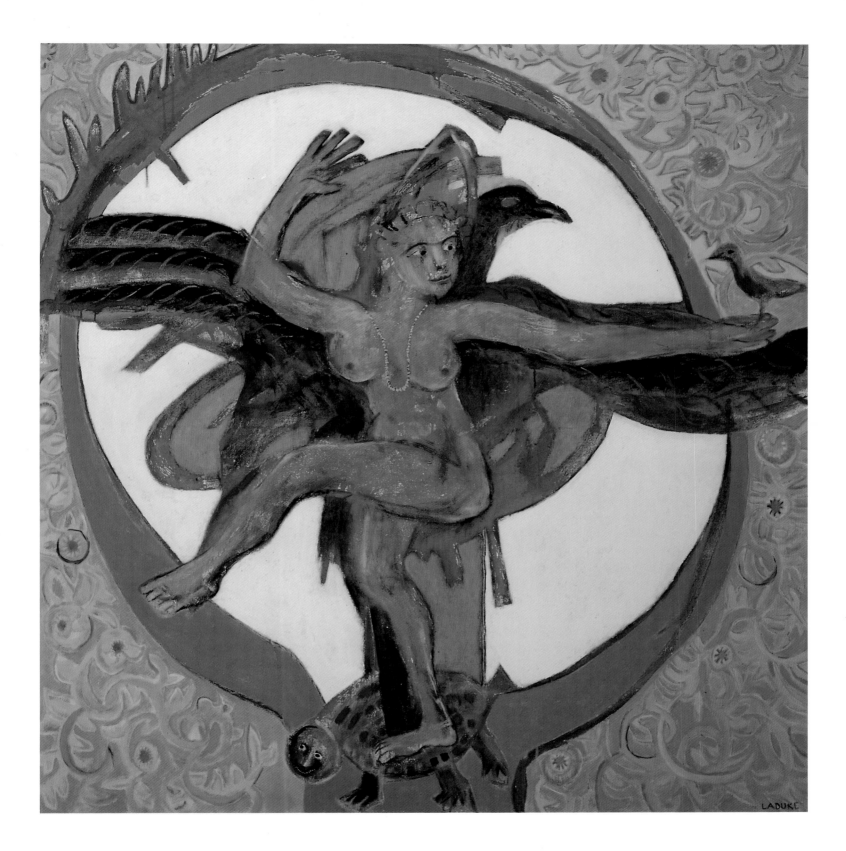

India: Creation Dance 1972, acrylic, 72 x 68 in.

The dance of creation, as performed by the god Shiva, here transformed by Betty LaDuke into a goddess of creation, establishes the rhythm underlying the creative journey made by the artist during her own vision quest, an expression of which can be found in this book. The iconography of the dance of Shiva traditionally links the human energies of Eros to the cosmic energies of the movements of the planets and the constellations. Shiva's dance incarnates the cosmic activity of the creator.

 Here a female creator dances upon a turtle (a symbol of the Earth, according to Native American tradition) within a sacred circle whose flames and blood-red energies surround and penetrate her body, activating her movements with the fire of the life force itself. Behind her looms a large, dark bird, indicating spirit flight. The theme of flight is echoed in the small, light bird she holds in her left hand, so that she encompasses both the light and the dark aspects of the spirit's journey within her being. Her right hand makes a commanding gesture, and her eyes burn fiercely as they telepathically create a cosmic covenant with the bird of peace.

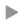

Oregon: Journey Homeward 1972, acrylic, 62 x 54 in.

Not surprisingly, our entrée into the artist's universe also begins with Betty LaDuke's 1972 painting *Journey Homeward*. Why begin with the journey home, with the voyage back to the nest, a return flight on the wings of a bird, accompanied by the guardian presence of the Woman in the Moon?

 As I spoke with Betty LaDuke in her Ashland, Oregon, studio recently, she reminded me that the fertility of artistic creation and the fertility of the Earth are synonymous with the fertility of the creation of life from the female womb. Here the personification of the moon links our human visage to that of the lunar deity, reminding us that the journey home is one part of a larger cycle, just as the full moon face is only one phase of the lunar cycle. Betty LaDuke's creative imagination takes wing and soars, encounters important symbolic creatures from myth and vision, but always connects her newly found, often fantastic, images with familiar stories of life in our daily human reality.

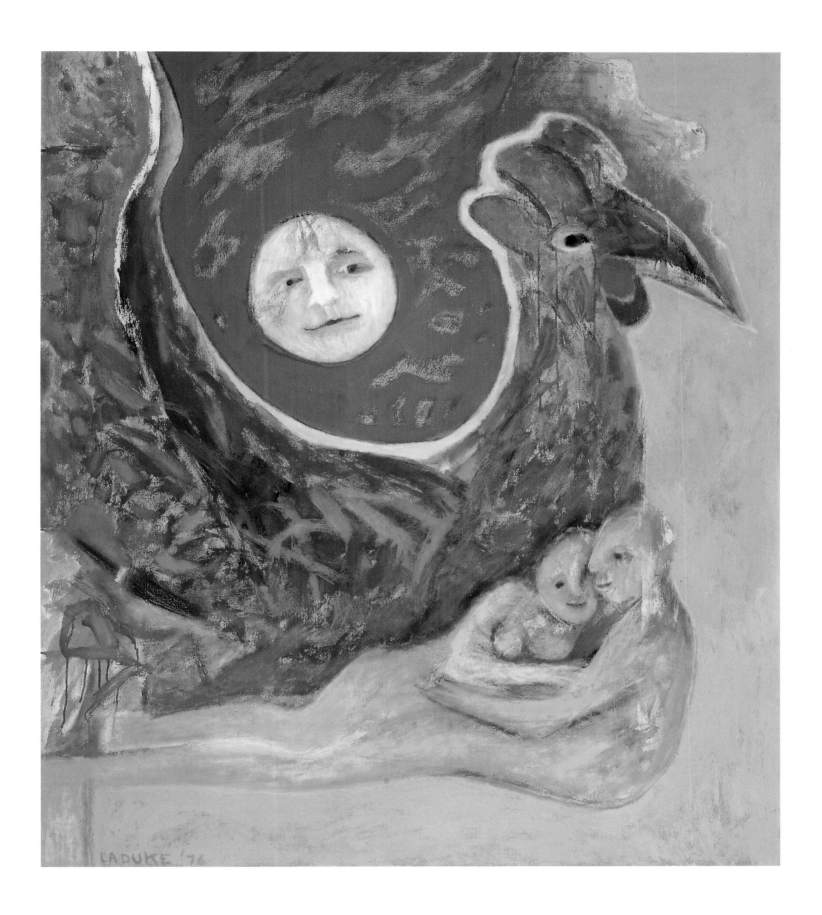

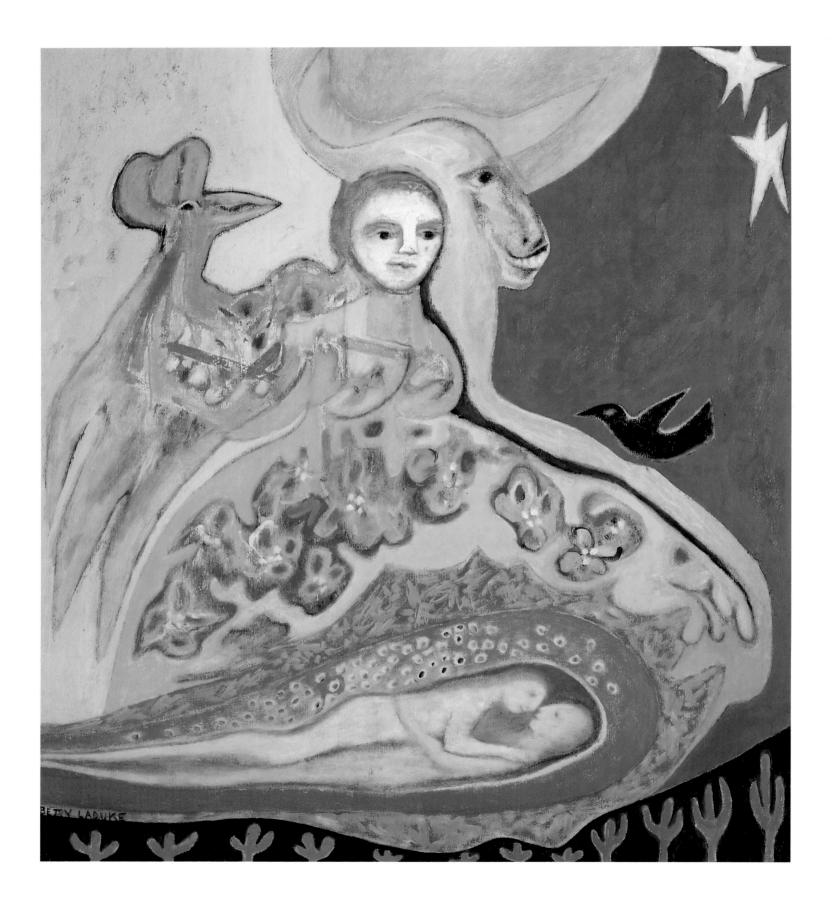

◀

Guatemala: Fertility Altar 1978, acrylic, 68 x 54 in.

The nesting image in LaDuke's work reminds us of the nested dolls from her Russian heritage. Here in *Guatemala: Fertility Altar,* the nesting couple resides in the lap of the Virgin, who is herself nestled in the greater cosmic nest, composed of bird spirits, animal spirits, the sun, the moon, and the stars. In Guatemala LaDuke observed that beans, rice, corn, and chicken offerings to the spirit of creation entered a cosmic cycle of fecundity and renewal. During the different phases of this cycle, via the intercession of spirit, gifts of fertility are exchanged, making possible the manifestation on Earth of the abundance with which the Great Spiritual Creator has blessed us.

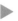On a symbolic level we may also conceive of a work of art as an offering and a personal sacrifice to the spirit or god/goddess of creativity. In a very deep sense, LaDuke's fertility altars are precisely what they claim to be, offerings the artist has made of her own fertile creativity to the spirits of abundance.

▶

Papua New Guinea: Chain of Being 1979, acrylic, 72 x 68 in.

Bathed in a stream of white light, which can also be perceived as an animal/generatrix, LaDuke animates the hook form of Papua New Guinea sculptures that connects the spirit of the masculine to the spirit of the feminine. In an ecstatic visitation of the female by the male-female life source/fecundator, the great chain of being is engendered in the womb of woman. This act is like a calling forth of the souls of new life, who appear to hover near the source of light.

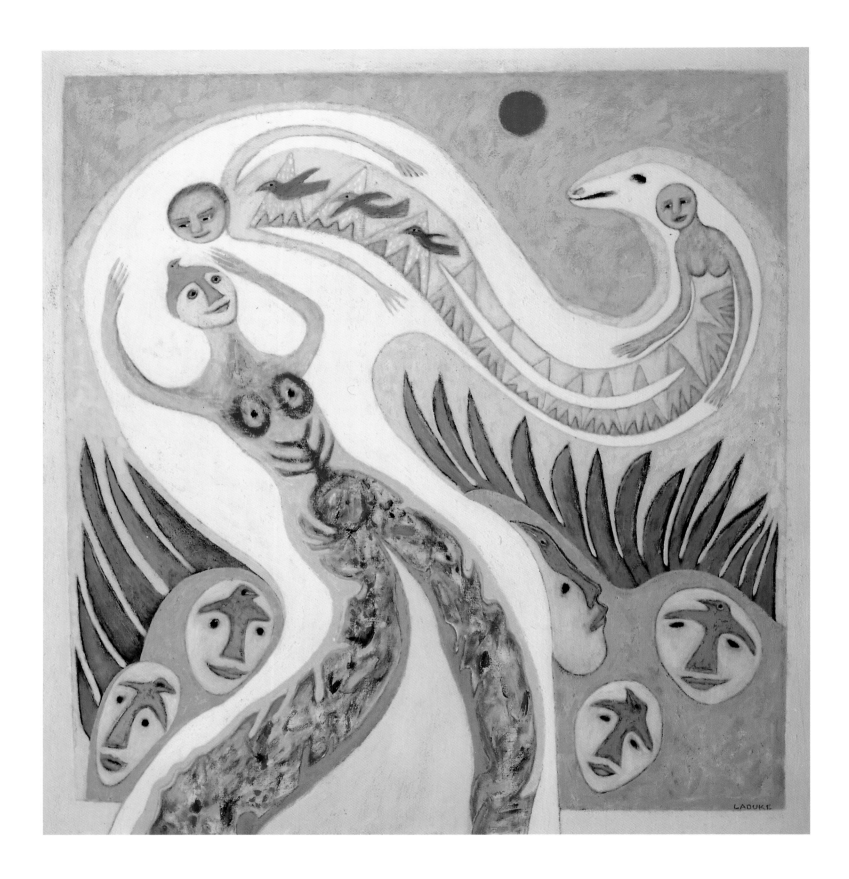

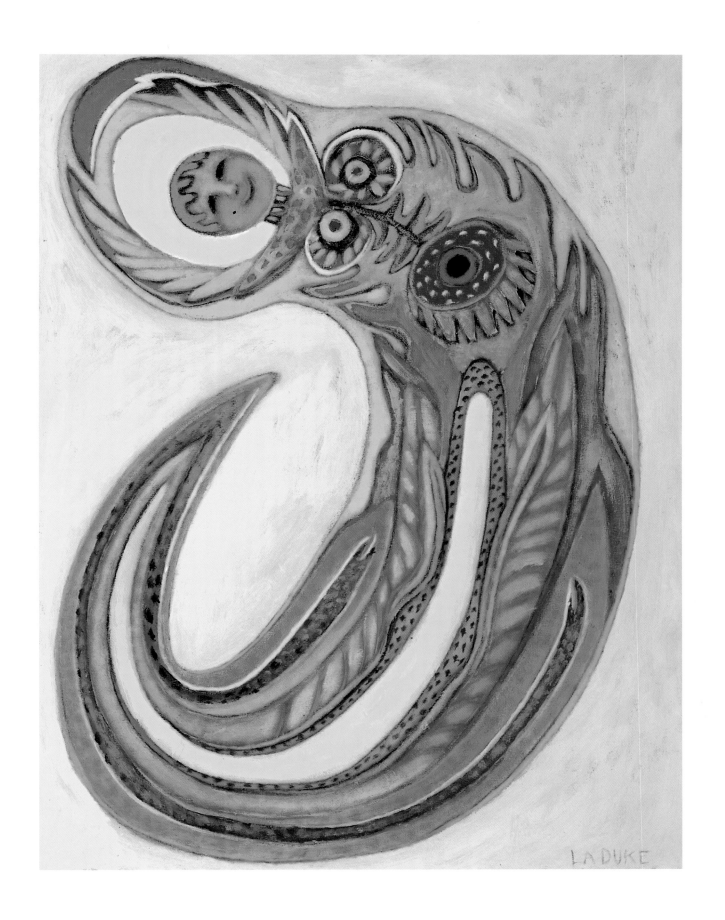

◄

Papua New Guinea: Fertility Spirit 1979, acrylic, 44 x 32 in

Inspired by the hook form seen in many sculptures from Papua New Guinea, LaDuke envisages an Earth goddess within that form. The artist's x-ray vision reveals the seeds of life in the womb of the fertility goddess, whose arms sprout like waves, flames, and leaves, circling around the golden aura that would have been perceived as invisible negative space had her arms not been uplifted by her joyous spirit. The interior life of the *Fertility Spirit* reveals that stems, stalks, seeds, flowers, light, water, branches, wings, and gendered forms in general all rejoice in a spiral dance of life in order to bring forth light in the world.

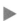

Africa: Creation Myth 1988, acrylic, 72 x 68 in.

The image of a Senegalese woman selling fish in the marketplace is inspired by this mythic metaphor of creation in which we are brought back to an awareness of how the wares we sell (fish) are actually the substances on which we subsist. We are composed of water, and our bodies are temples inhabited by the spirits of the water beings whose energies we have consumed. The fish that are brought to market and that nourish us have influenced our human lives to the extent that our embryos have passed through many stages of fetal development in the form of a fish.

Here the Mother goddess floods the world with the emanations of her fecund and creative spirit just as the Senegalese woman floods the market with the fish she sells. She nurtures the fish as if they were her own children, and, in a larger sense, when they are eaten they will nourish the embryos of her future children. We are reminded that in the most sacred way we become what we eat, and that what we eat is also becoming to us.

▶

Africa: Osun Magic 1991, acrylic, 68 x 54 in.

The color of the goddess Osun is yellow, the color of the sun's energy. In this painting LaDuke sees the past, present, and future unfolding in the light of goddess energy. Osun looks in all directions, as do the spirit doves that energize the powers of creation she wields in her hands. All the future births of animals and humans hover around her fertile labyrinthine womb, like incandescent souls awaiting rebirth.

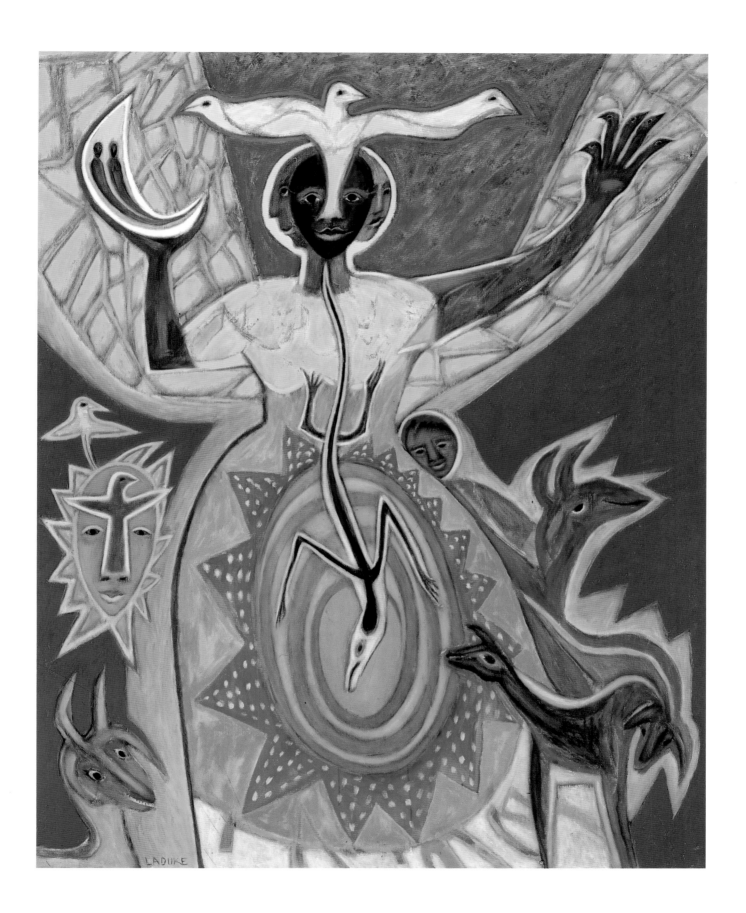

birth and nurturing

2

While Western patriarchal cultures have identified women with nature and undervalued the traditional "feminine" roles of mother and nurturer, a multi-cultural perspective on motherhood is empowering for women. As Betty LaDuke casts her artistic gaze upon women around the world, she discovers the potent analogy frequently made by indigenous peoples between the Great Mother, supreme creator of all life, and the human, biological mother.

Indigenous peoples often view both life and time in a cyclical rather than a linear manner. Thus, women's bodies with their moon cycles and their procreative potential are envisaged as powerful vessels of life, of transformation, and of cyclical regeneration. Women's bodies are the temples whose portals connect us with the great beyond and its spiritual mysteries: it is in women's bodies that the seeds of life are carried, that souls are made into human offspring, and it is through women's bodies that all the generations of human life must pass.

Although primal peoples have often attributed the "feminine" gender to the Earth, their definition of "the feminine" differs vastly from our own. In India, for example, the Earth is gendered as "feminine," and the "feminine principle," known as "prakriti," is considered to be active, alive, and creative, whereas in the West "the feminine" is characterized as passive, inert, and yielding.

Betty LaDuke's art brings to life "the feminine" as it is conceived of in cultures that revere the Earth and worship the Goddess, both in her cosmic oneness and in her earthly multiplicity (river goddess, tree goddess, goddess of the animals, and so on). Thus, a multi-cultural view of women and nature enables us to perceive the acts of birth and nurturing as dynamic and powerful, as well as spiritually and materially vital to the survival of all life. As Betty LaDuke depicts the birthing and nurturing processes, she makes visible the ways in which all forms of life enter into human procreation; for we are nourished by the animals and the plants, whose beneficent qualities form and nurture all creatures. We are, then, interrelated with all living things, and human birth and nurturance are good for nature just as nature's fertility is good for humans. In LaDuke's work, human motherhood is also a metaphor for all types of creative labor and fertility.

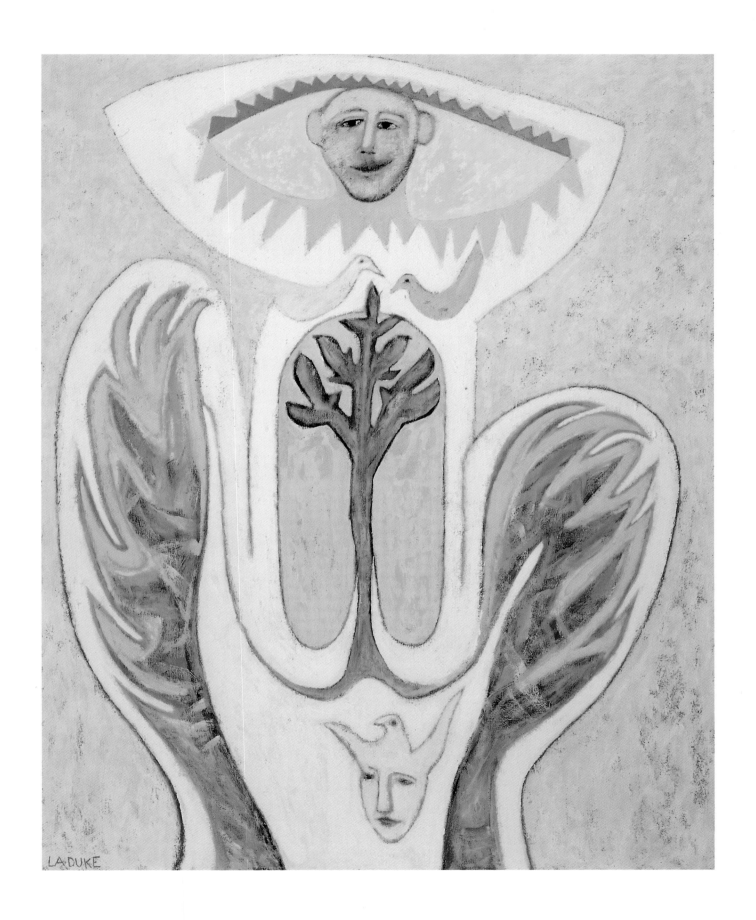

◄

Borneo: The Welcoming 1980, acrylic, 68 x 54 in.

The second stage of our *Journey Homeward* is *The Welcoming*. *The Welcoming* is inspired by an Indonesian birth ritual in which the mother's body is the tree of life, nurturing and developing the seed and preparing it for growth.

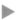

Borneo: Iban Birth Rite 1981, acrylic, 68 x 54 in.

In *Iban Birth Rite,* inspired by her visit to Borneo (Sarawak), the artist was drawn to the "puas," the sacred blankets woven by women specifically in order to receive the newborn child. In LaDuke's metaphoric comparison of the weaving of the blanket with the weaving of the fabric of life, the artist implies another comparison between the womb and the loom.

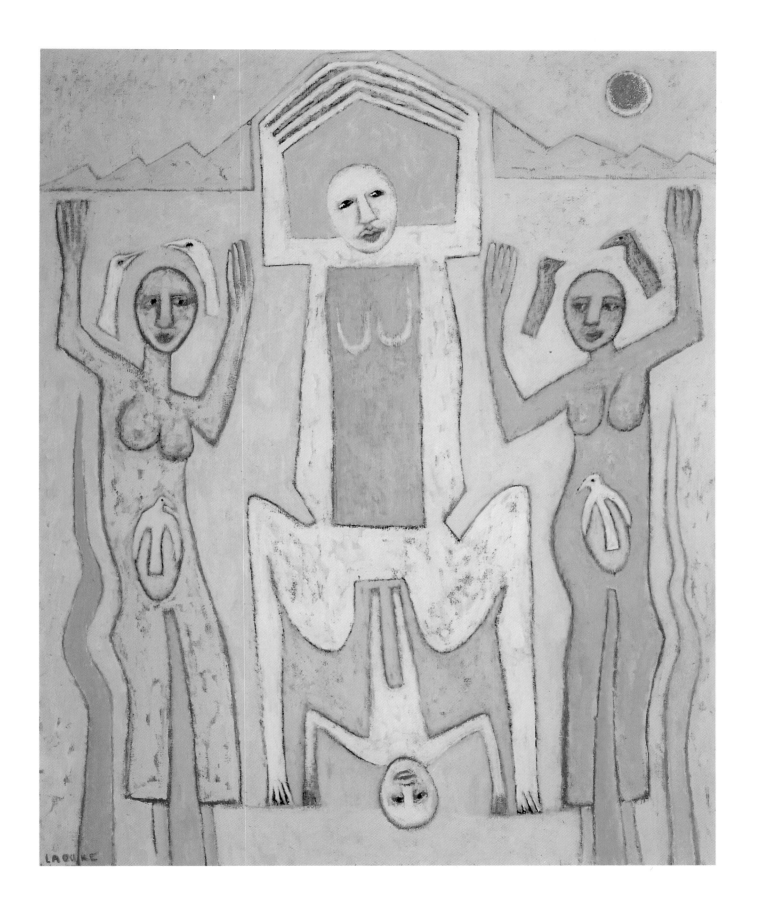

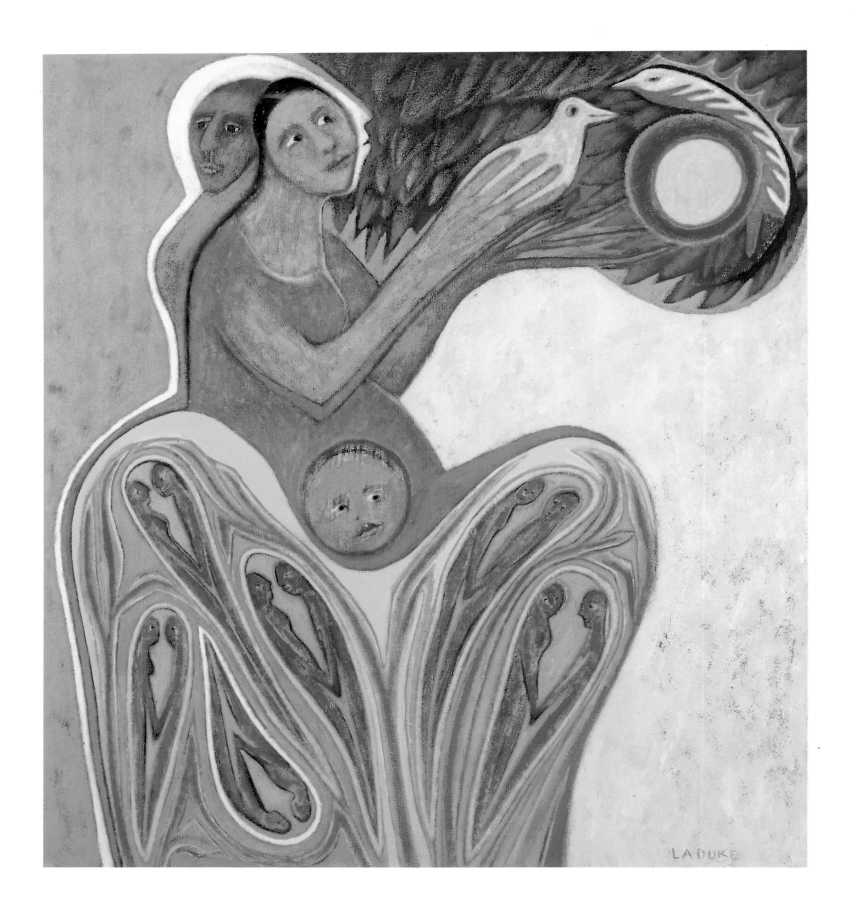

◀

Latin America: Homage to the Mothers of the Disappeared 1984, acrylic, 62 x 54 in.

Life should appear and disappear in a natural, organic way. Death, when it comes in old age, is a
part of the sacred life cycle. Unfortunately, Latin American mothers often give birth to life, only to witness
its disappearance through political kidnappings and torture. Their children are the victims of the crimes
of political oppression.

In her *Homage to the Mothers of the Disappeared,* LaDuke honors the powerful life force of these
mothers, who, despite their deep sorrow, open to love again, move through their darkness, and bring
forth more souls into the light. These women support each other in their grief as well as in their reaching
out to new forms of affirmation.

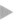

Latin America: Timeless Time 1984, acrylic, 68 x 54 in.

We see the souls of the dead children being carried to the light by the yellow birds. In the depths of
timeless time, these children will be reborn. Love and life spring eternal, and their energies will bring
about a reseeding and reflowering of the tree of life.

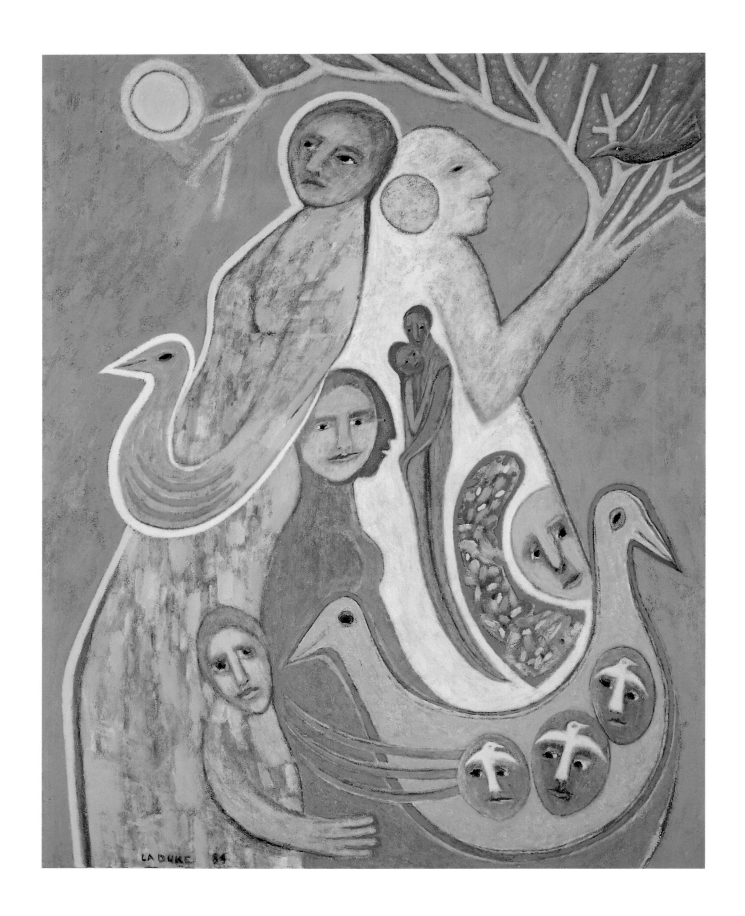

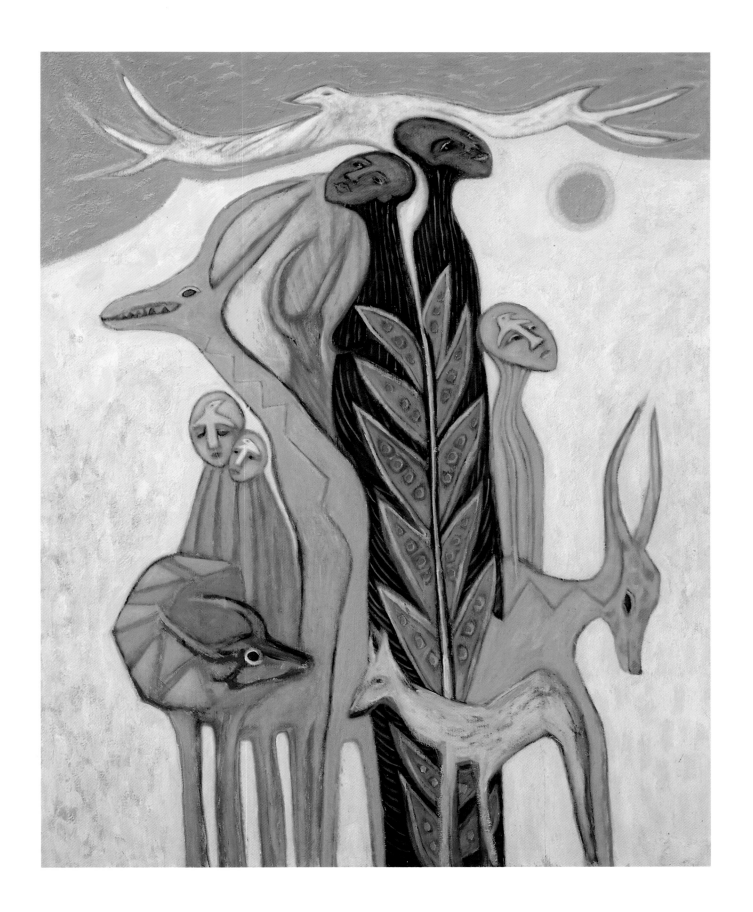

◀

Africa: Masai Tree of Life 1988, acrylic, 62 x 54 in.

This tree of life was inspired by Kenya's nomadic Masai people and their cattle. The Masai have refused to assimilate to the mainstream culture. They proudly maintain their allegiance to the land and to their cattle herds. Mother and father are united in the single tree, which connects many generations of humans, plants, and animals to the spirit of fertility and generativity across space and time.

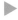

Africa: Rain Chant, Dawn 1988, acrylic, 68 x 54 in.

While watching her daughter nurse her granddaughter, the artist conceived of the child's cry for milk as a kind of rain chant. Our human mother then becomes a cloudburst and a rainfall for the infant, a rain goddess for her offspring. Certain Dogon sculptures with arms uplifted also caused the sky to bring down the fertile powers of the rain, thus quenching the thirst of plants parched by the fiery rays of the sun they basked in. The turning of plants and children toward the sky and the mother for both sun and rain is a natural tropism found in all growing things.

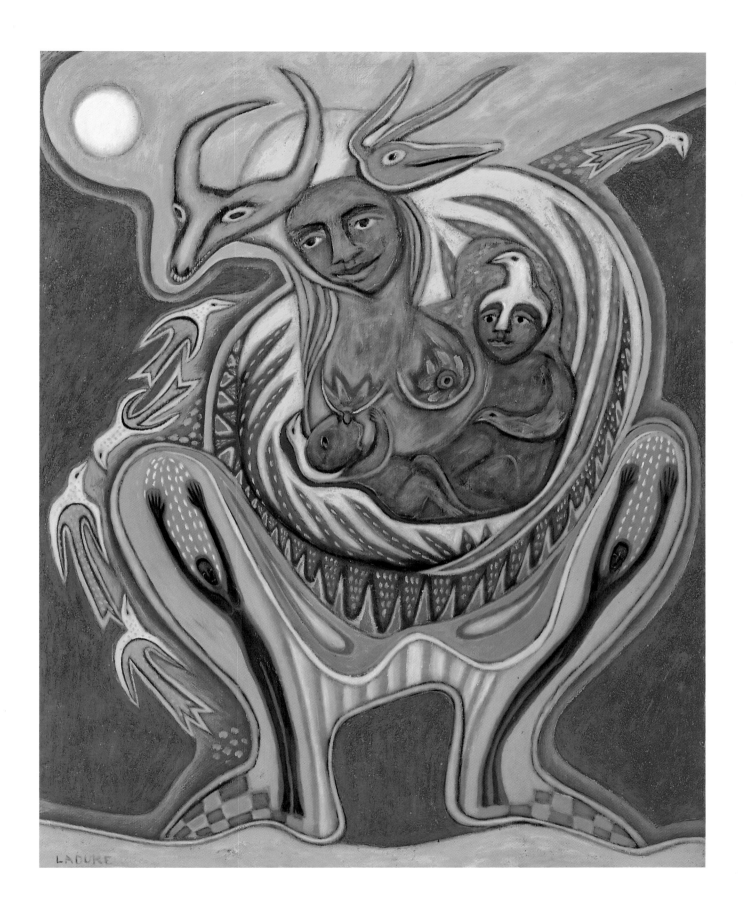

▶

Africa: Madonna 1989, acrylic, 72 x 68 in.

The African Madonna's blue garment is speckled with actual cowrie shells sewn onto the canvas. Depicted in the posture familiar to us in the West of the Virgin Mary with the Christ child, this Madonna celebrates the earthly energies and the sexual powers of the male and female forms. They rise from her roots in the Earth and float through the yellow auric fields of her thighs to approach her sacred earthly womb. On her head, which faces past, present, and future simultaneously, sits a bird whose wings are horns of light. These horns shelter the children, who, like dancing tree spirits, reach beyond the Earth into the cosmos for radiance.

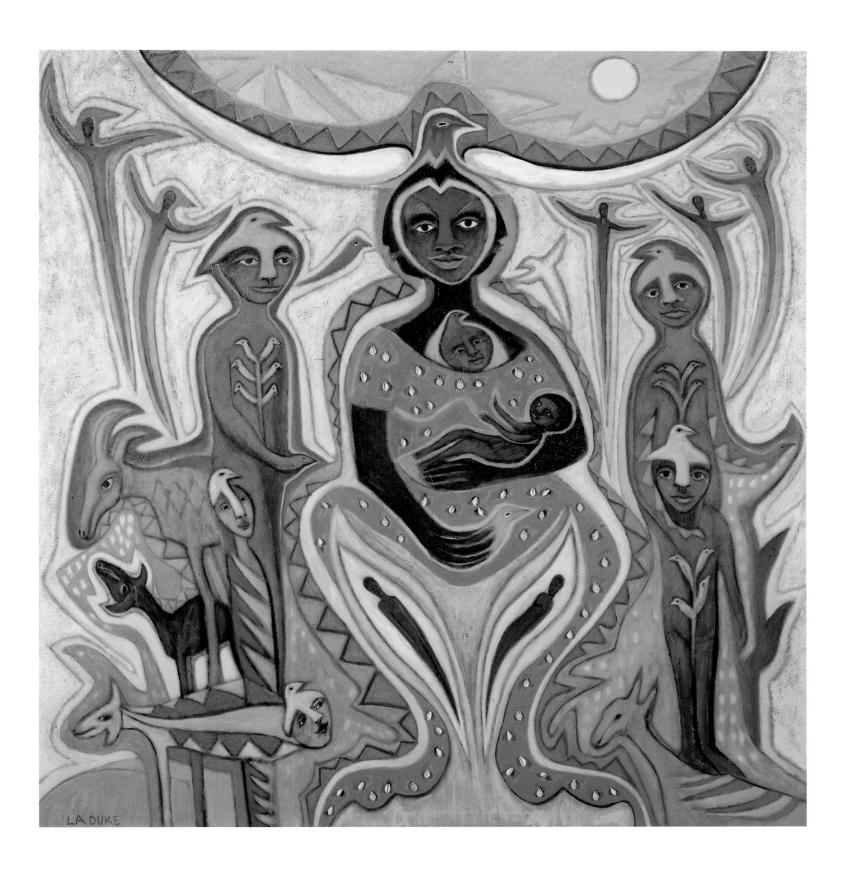

▶

Africa: Osun Rainbow 1990, acrylic, 68 x 54 in.

When the Osun rainbow manifests, both celestial and terrestrial beings come out to observe the miracle of creation as the Great Mother goddess gives birth to the Earth (here symbolized by the turtle). Within the Great Mother's mythic being arises the potential for all forms of life. Her entire body is a vessel of transformation in which matter comes to life from light and is propelled into the world by the spirit guide, the light bird being, that encircles the Black Madonna's triple faces and merges with her rainbow of miracles.

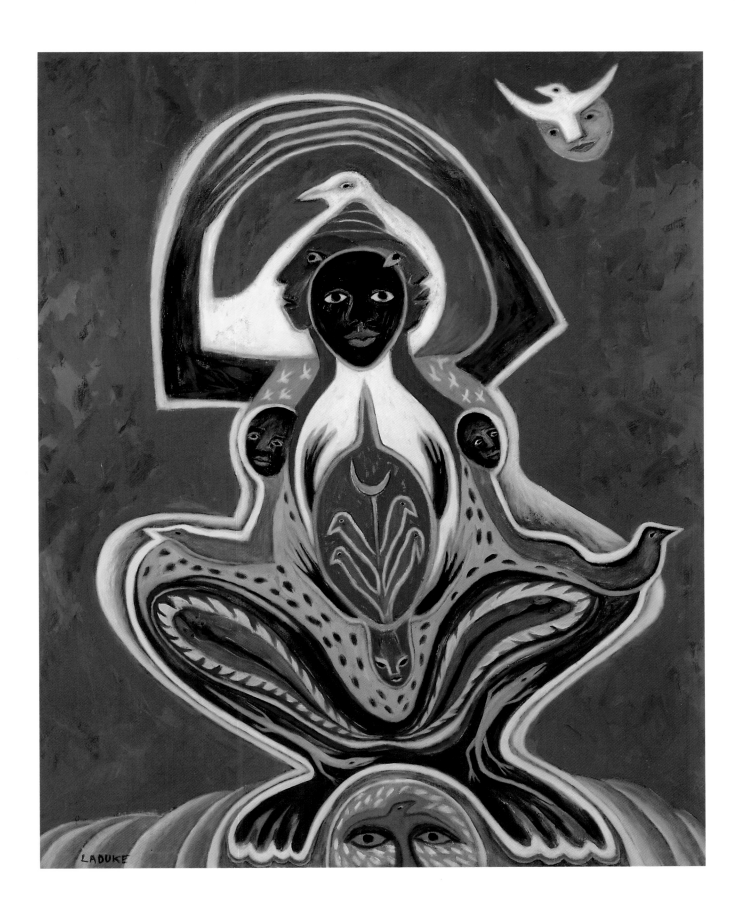

▶

Africa: Spirit Mother 1991, acrylic, 68 x 54 in.

Inspired by the powerful women she observed in the African marketplaces, LaDuke depicts the women holding bunches of bananas on their heads, crowned by the sunlight. This spirit mother's body is filled with future earthly creatures still awaiting their own births. The turtle, symbolizing the Earth, absorbs the spirit power that travels through the channel of her third eye and bathes her Earth-child in a seeded yellow light, causing plants, animals, and humans to grow.

Her arms carry the male and female of our species, and it is clear that humans are part of the Great Spirit Mother, but that her power transcends both gender and nature in all their variety. She is the supreme creator, the source of the many potentialities of life—of the forms that no longer exist, of those that exist at present, and of those that will only come into being at some future time. Like the birds in her radiant halo, these future life forms are nourished by the Great Mother's spirit of vegetation.

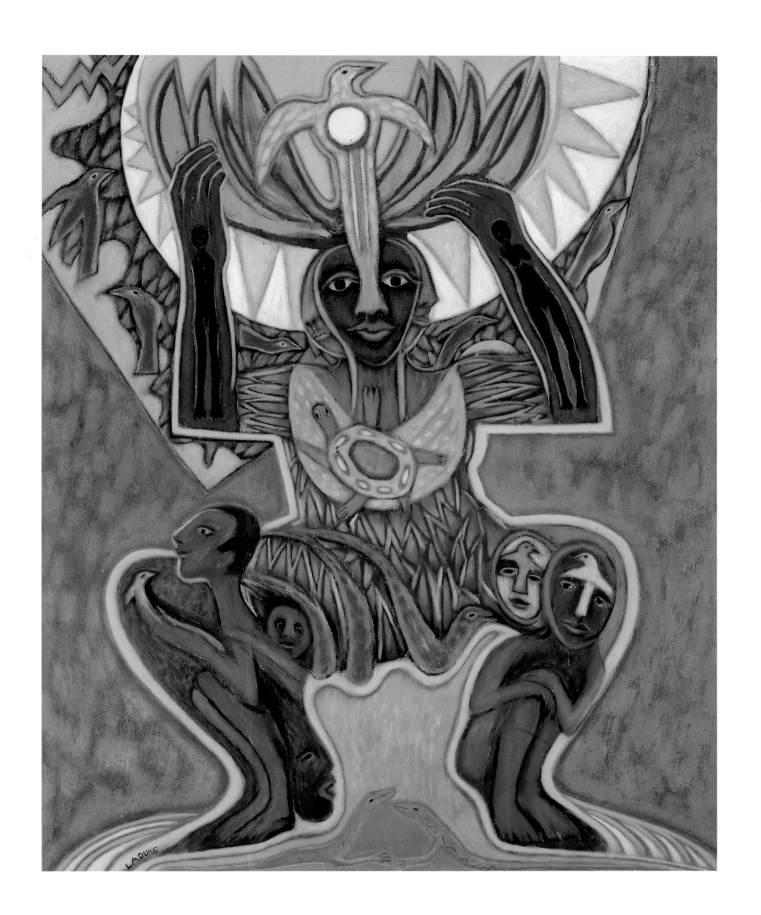

children: being and becoming

In a third stage of the artist's life journey, she focuses on her relationship to her own children within Western culture, and suggests comparisons and contrasts with children's lives in other parts of the world.

LaDuke interprets the plight of children worldwide as she would that of a colonized or marginalized people. Her empathy with the children living under political oppression is, I believe, original in the visual arts, where children usually appear only in portraits or in domestic scenes. They are not treated as subjects having a political drama of their own. Here, in the work of Betty LaDuke, they are. Perhaps the fact that her own daughter, Winona, is an activist on behalf of Native American peoples formed the artist's awareness of the value to the present and the future of the youth of a culture. To my knowledge no artist has interpreted children's lives from this politico-spiritual perspective. Not only are children valued by the artist as potentially important participants in the social struggles of their countries, but they also are understood to represent the future of the world.

Native Americans base all their important decisions on how they will affect the seventh generation to come. LaDuke's deep sorrow over the loss of young lives through political kidnappings and war expresses her long-range vision, in which she sees current wars as robbing the present and ultimately the future of the creativity and the more ethical leadership of its citizens. Sadly, she has observed that in many colonized countries, the young are living through a serious and real form of genocide.

◀

Oregon: Jason's Journey 1972, acrylic, 68 x 54 in.

Jason's Journey is about the artist's son's growing up and finding his own pathway from darkness to light. He is being guided toward the light by a bird, his spirit guide. This painting functions not only as a representation but also as a talisman. A work such as this also contains the artist-mother's loving and protective, creative energies, which, when given this form, bring about the needed protection for the child in question.

Oregon: Winona, the Parting 1976, acrylic, 68 x 54 in.

Here the artist focuses attention on her daughter, Winona, and her departure from home for college. As she grows up, Winona wraps her arms around herself and moves into her own space and time. While in the West our children are encouraged to develop their own individuality and creativity outside of the collectivity, in other countries young children are guided to socialist ethics or are trained to participate in a more communal vision of society. Winona, who is partly of Native American heritage, has become an important activist on behalf of America's indigenous peoples.

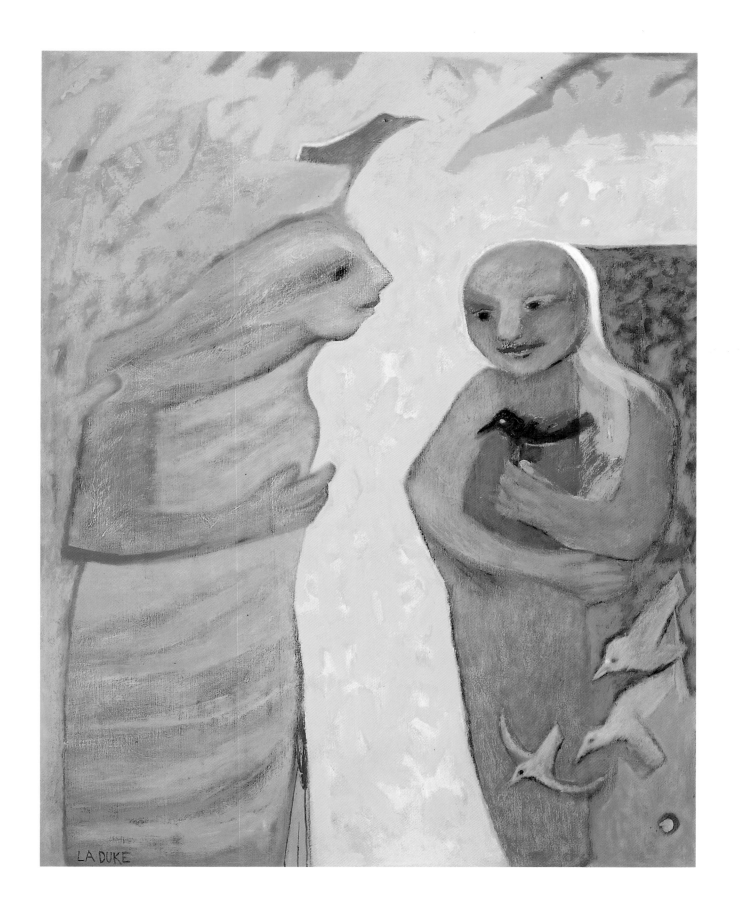

LA DUKE

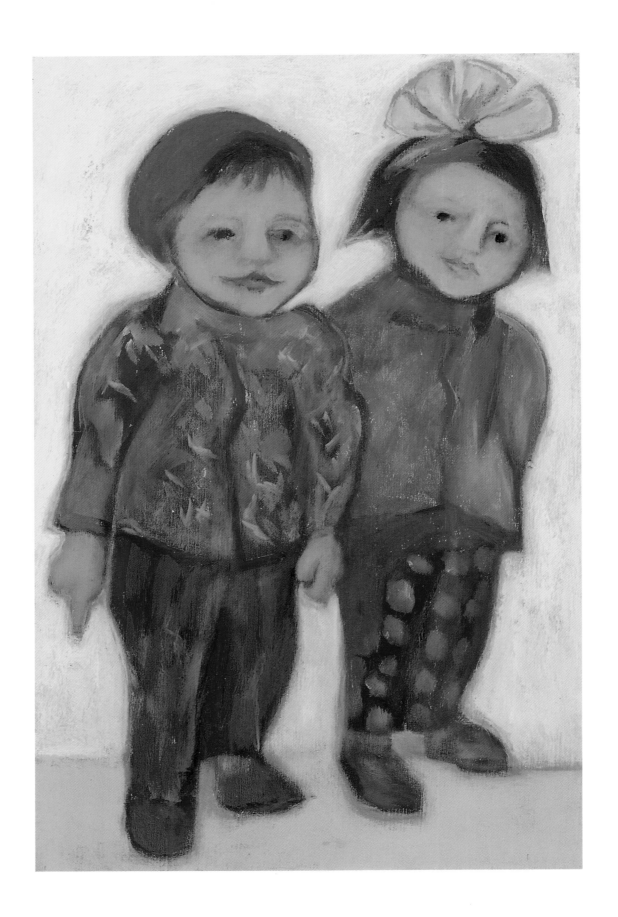

◄

China: Nursery School Children 1977, acrylic, 44 x 32 in.

Whereas American children seek their individual and private paths, children raised in communist
countries are taught to harmonize with the group, to conform to patterns of behavior and life choices
based on communal ideological assumptions.

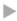

Central America: Children in Transition 1982, acrylic, 72 x 68 in.

In contrast to the individual, private paths chosen by American children and the collective vision that
communist children adopt, the artist views the children of Central America as children in transition.
These young children may be deprived of those years of individual introspection and path finding, as
well as of the years of harmonious co-creation in socialist projects, for they may have to carry rifles
instead of pencils and plows while they are still in their teens. On the extreme right of this painting the
mother holds her toddler and looks out into the future with sorrowful eyes. Will war come to rob these
young men of their adolescence? Will they have to join revolutionary guerrilla movements instead of
peaceful youth organizations?

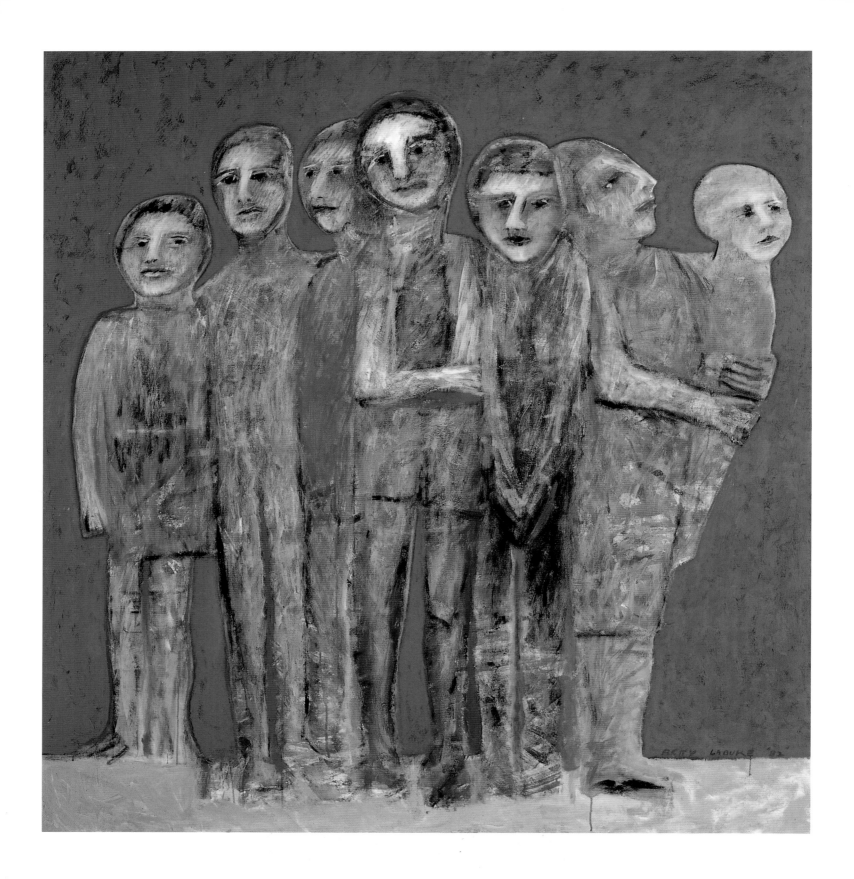

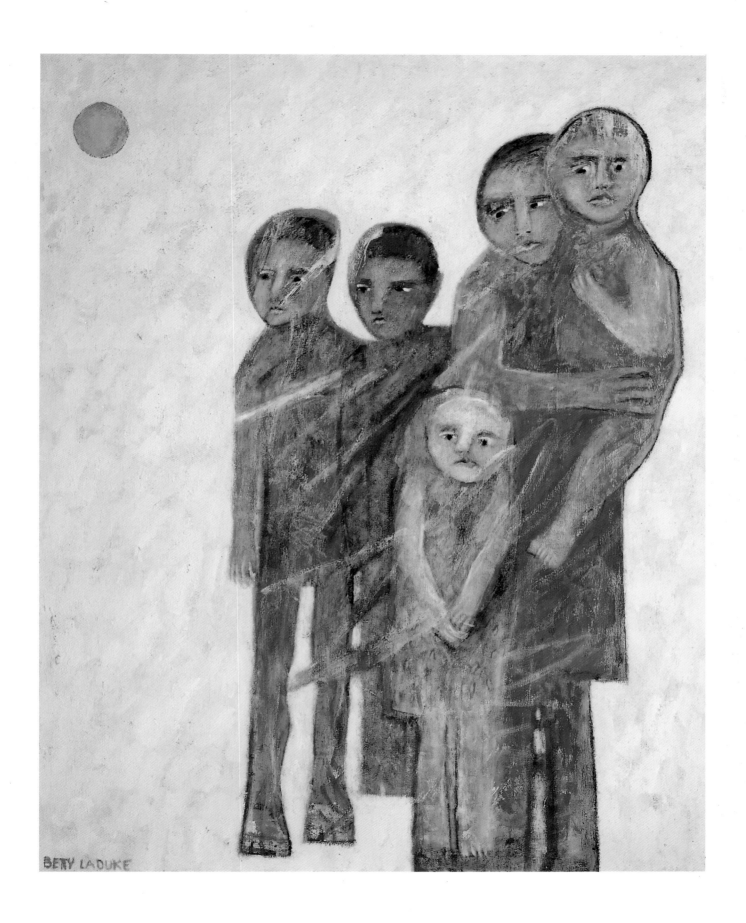

◄

Chile: Children of the Disappeared 1982, acrylic, 68 x 54 in.

In this painting we see the desperation on the faces of the children who live near Santiago, the capital of Chile. Here in crumbling dwellings one can find hundreds of thousands of children who have no food, clothing, or heat in the winter. LaDuke's contemplation of the plight of young children stresses the harm we do to future generations through perpetuating the values of a civilization that colonizes indigenous peoples, rapes the land, and exploits women and children via the spread of so-called "development" and political terrorism.

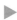

Africa: Goat Boys 1989, acrylic, 72 x 136 in. (diptych)

This diptych focuses on the fertility and life force of youth who are raised in harmony with nature. These boys do not leave their homes alone, but go into the world accompanied by the animals—their guides, their teachers, and their friends. In *Goat Boys* we see the world of nature growing within the boys' bodies and filling their torsos and minds with images of the spiritual powers that arise from tending nature and interacting with plants and animals in ways prescribed by sacred tradition.

 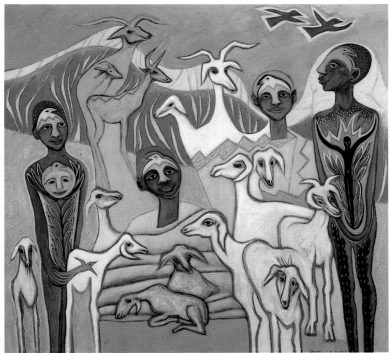

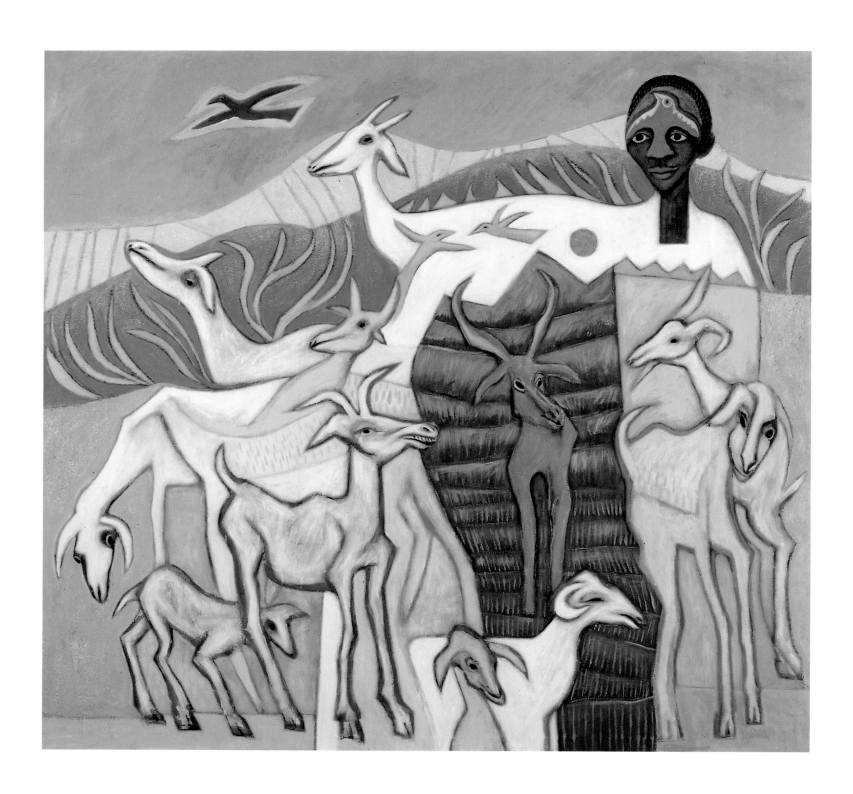

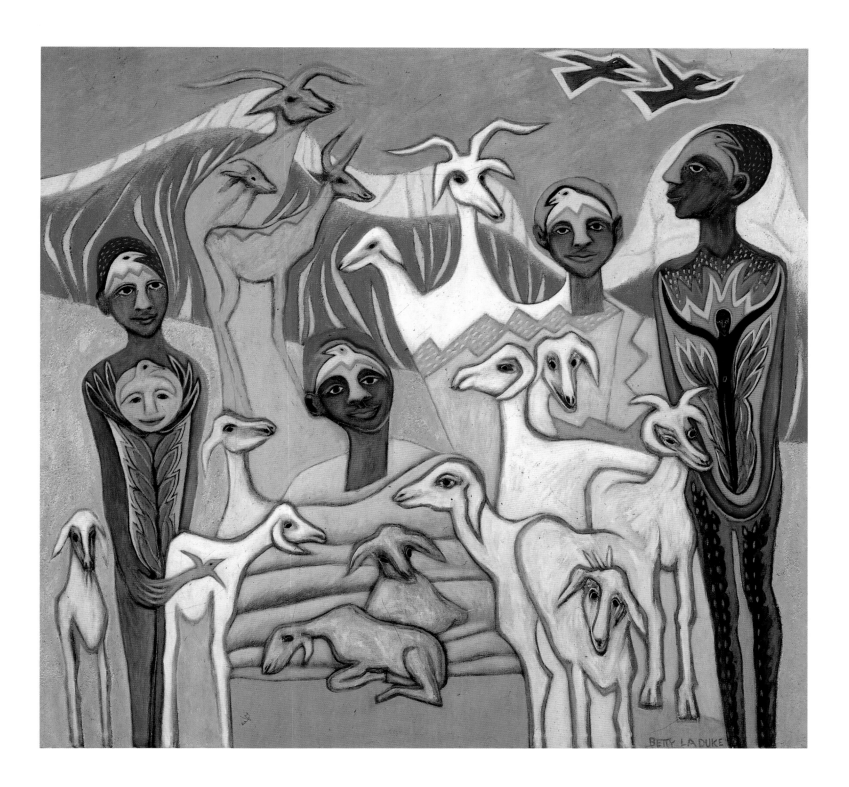

▶

Africa: Sunrise 1989, acrylic, 68 x 54 in.

In these last four paintings focusing on African children, LaDuke offers us images of hope for the future arising from the traditional values of African cultures. *Sunrise* depicts the rhythms of life awakening from the darkness of the dreamworld to the light of a new day. The seeds of life that burst open in the morning emit a perfume that calls out to the animals, who are sisters and brothers to the human children and are equally embraced by the elders.

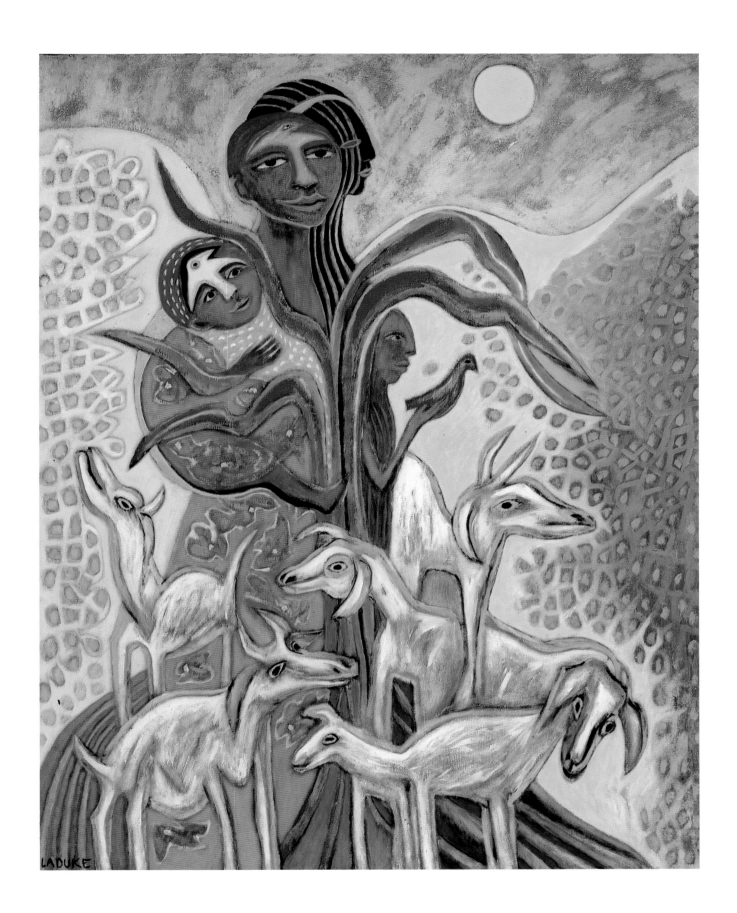

▶

Africa: Osun's Children 1990, acrylic, 72 x 68 in.

Osun's children have gathered around her and have manifested her sacred presence in them by becoming powerful healers. Osun is depicted with extra heads, which represent the phases of her interaction with the spirit family from past to present to future, from here and now to the beyond. Here the masks derive from within and without, from our creative imagination as well as from the cosmos. These masks gaze out upon creation with the eyes of cosmic and spiritual vision.

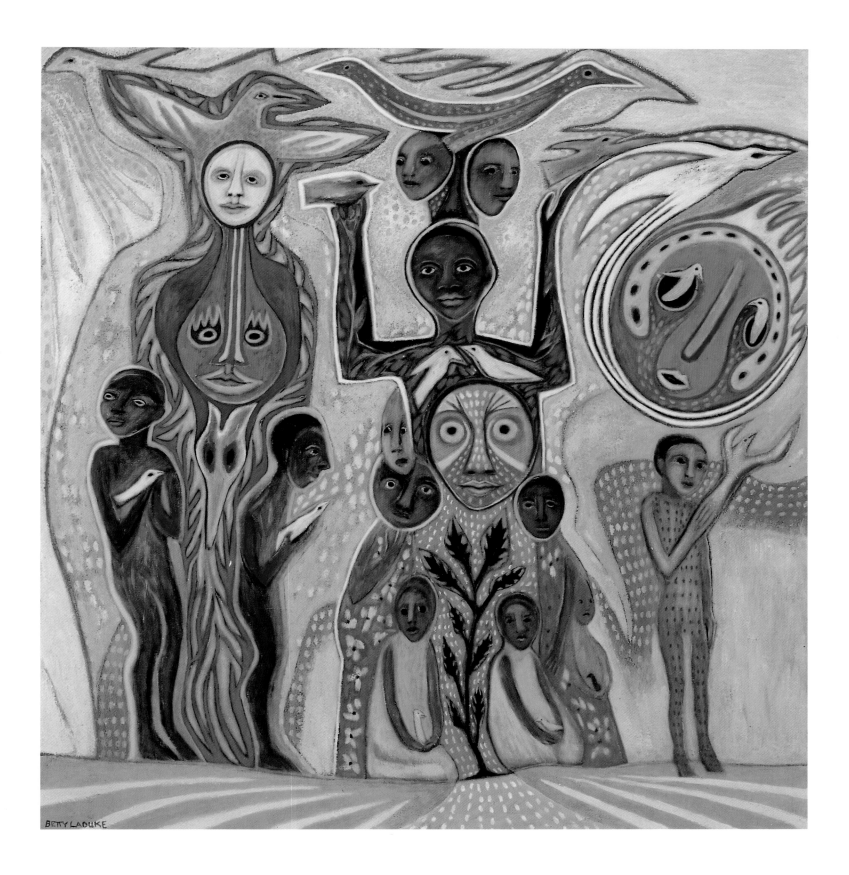

BETTY LADUKE

▶

Africa: New Life 1988, acrylic, 68 x 54 in.

African children live in intimate connection with the mysteries of birth and death. The young cow outlined in white light symbolizes the spirit of all the cows of the past and the future. African herders who have witnessed the birth and death of the animals they tend are less afraid of the mysteries of life than are children in a Western urban setting, where birth and death have become medicalized and removed from the context of daily reality.

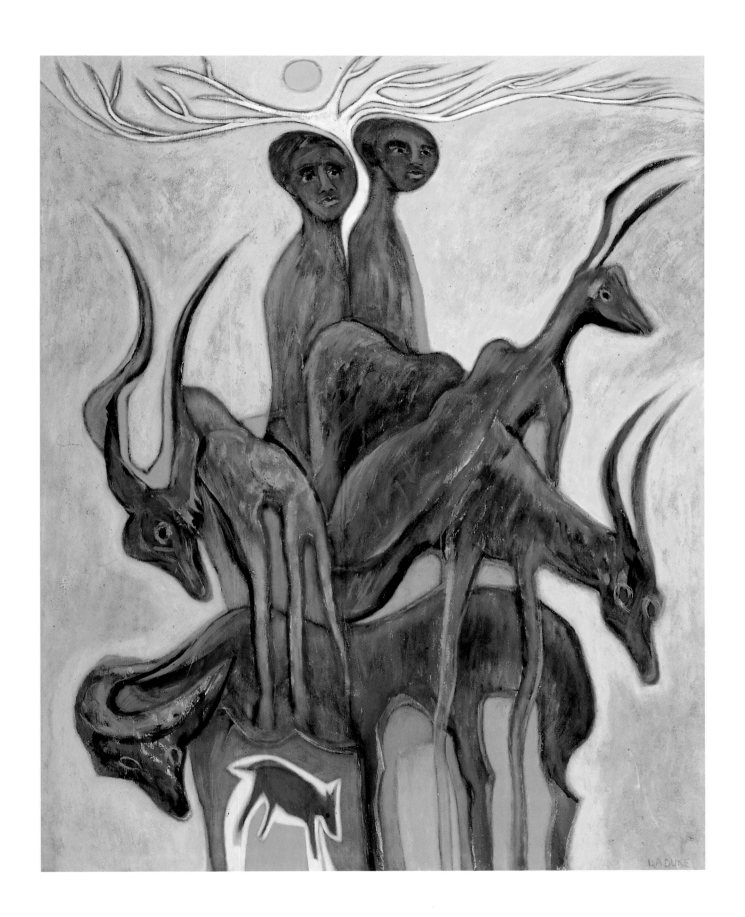

4 courtship and marriage

Courtship and marriage are here understood from a cross-cultural perspective. In these works Betty LaDuke often makes reference to her home in Oregon and to her own marriage to symbolize not just earthly, human marriage but all kinds of sacred marriages.

These paintings make visible to us the many ways in which humans are "wedded" both to the land and to the spirit world, as well as to their human partners. Love, courtship, and seduction rituals play important roles on all of these levels. In order to draw the spirits down to bless the couple, the newborn child, the land, the animals, and so on, all rituals employ the seductive powers of numerous and diverse sensuous elements such as perfumes, incense, offerings (gifts), costumes-as-masks, poetry, flowers, sacred objects, artistic artifacts, and many other forms of allurement.

In human courtship we have the opportunity to refine our skills and prepare ourselves for the love and reverence we bring to the unseen forces that guide us—the ancestors and the deities, whom we seduce into blessing our lives in this dimension, here on the Earth plane.

In Betty LaDuke's work, humans, animals, plants, and spirits constantly mate, exchange energies, and take part in the cosmic dance of life via the power of love.

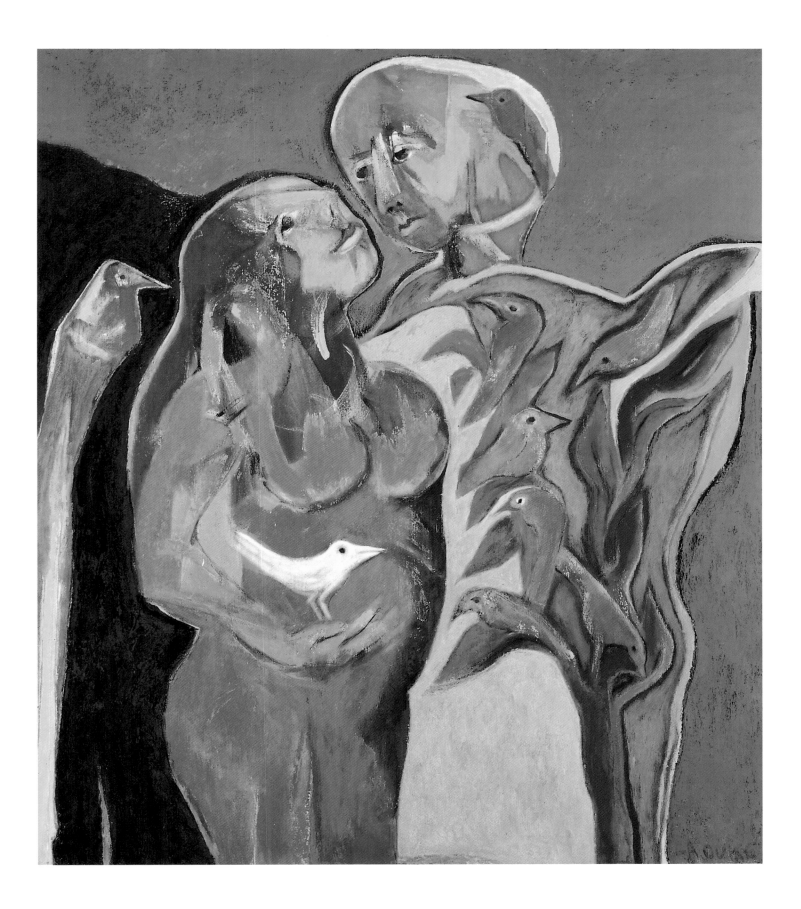

◄

Oregon: Summer Joy 1972, acrylic, 68 x 54 in.

In *Summer Joy* LaDuke associates birds with love, for they represent both nesting (as depicted in the body of the man) and freedom to fly (the white bird that alights on the woman's hand).

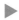

Oregon: Whale's Head 1978, acrylic, 68 x 54 in.

In *Whale's Head* the male and female forms grow solidly from the rocks on the Oregon coastline, so that the imprint of the couple's love is both birthed by the landscape and carved into it to remain an eternal, natural monument to love.

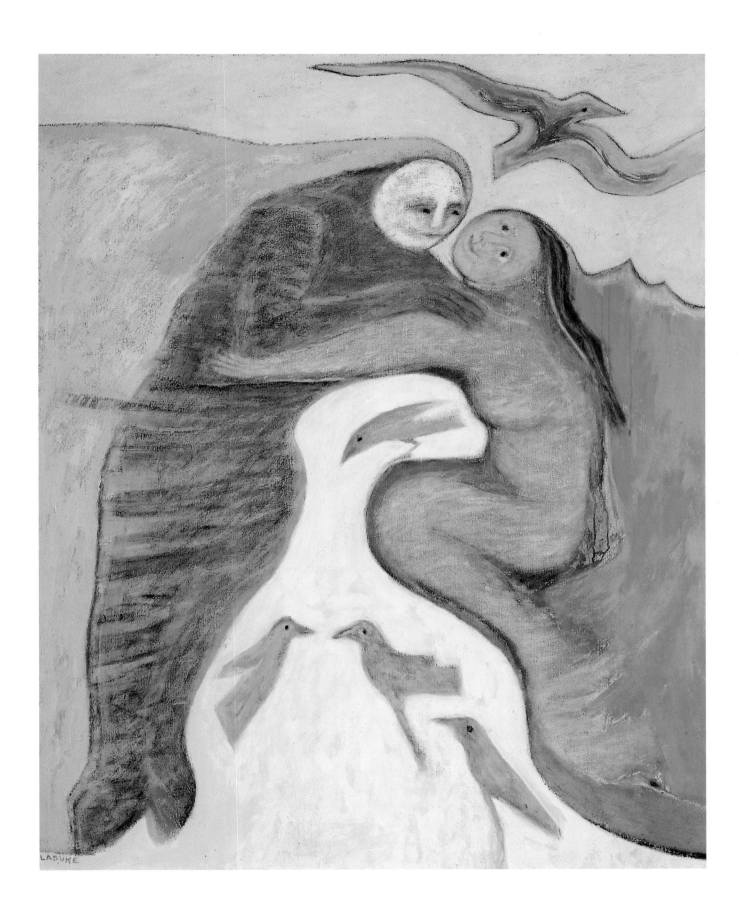

▶

Oregon: Ocean Waves 1978, acrylic, 68 x 54 in.

This painting celebrates the love that blossoms and reblossoms cyclically, like the waves that rise and fall.

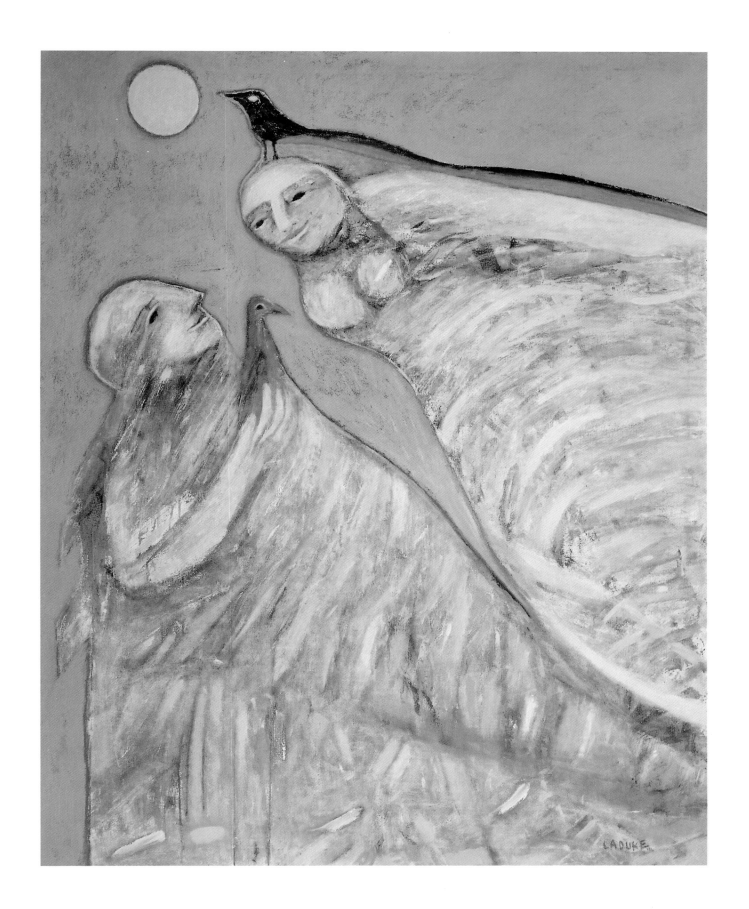

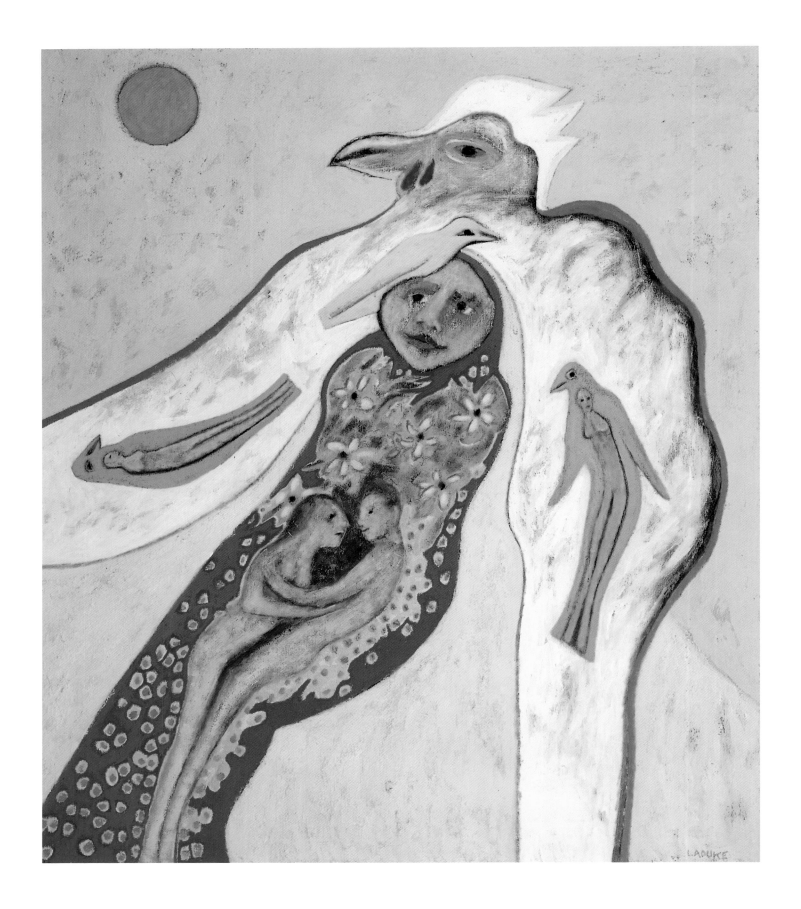

◀

Oregon: Summer's End 1979, acrylic, 68 x 54 in.

At summer's end, the mountain peak becomes the bird's head as the Oregon landscape takes on the qualities of the lovers' lives and the rock's spirit begins to soar.

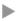

India: Hindu Wedding 1973, acrylic, 72 x 68 in.

The present and future meet at the moment in the wedding when the expectations of the bride and groom are communicated to each other. The bride hopes to be fertile. This is symbolized by the cow's head that appears over her in spirit. The groom already carries his heir upon his shoulders. The couple is encircled by a cord that they must untangle as a test of their patience with each other during their marriage.

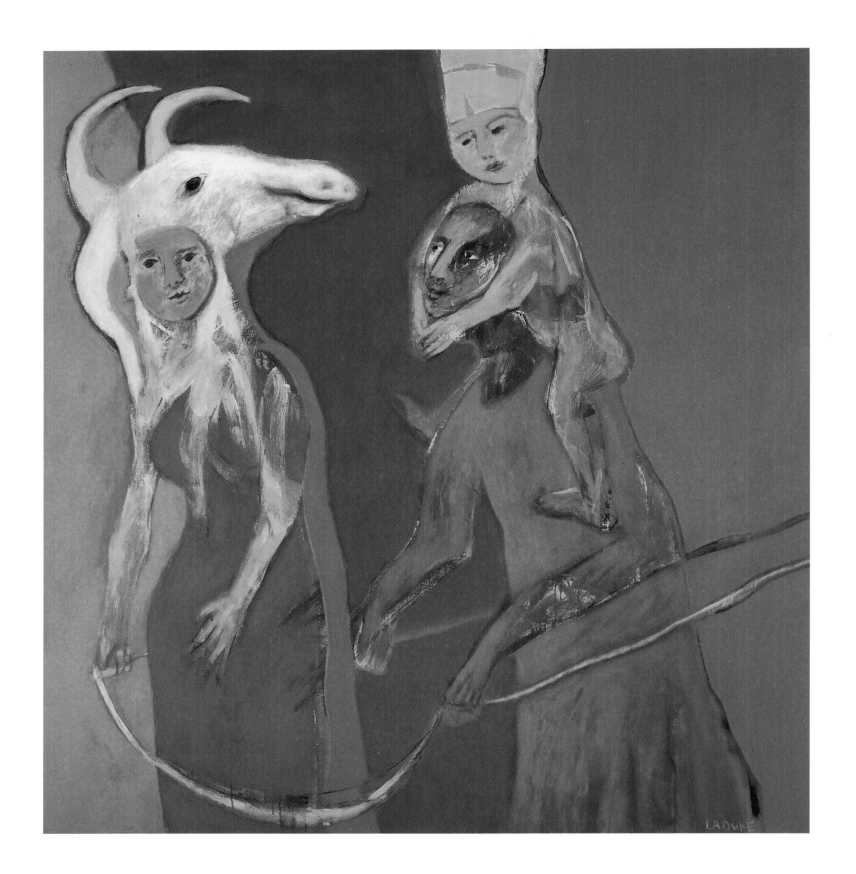

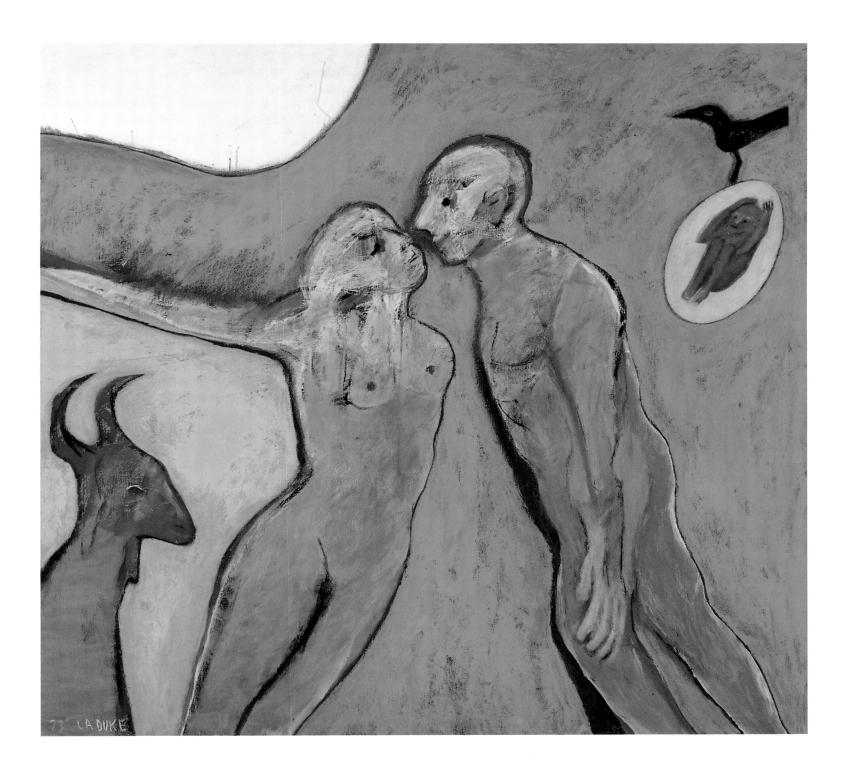

◀

India: The Taj Mahal 1973, acrylic, 72 x 68 in.

The Taj Mahal is dedicated to the Raja's wife, who died during the birth of their fourteenth child. It is a permanent structure intended to embody the passion between the Raja and his wife. Their love looms very large compared to the death image of the figure within the egg that is carried off by the blackbird. This is a joyous, sensuous architecture that celebrates life and love.

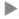

Papua New Guinea: Hidden Masks 1979, acrylic, 68 x 54 in.

This complex image refers to the masks worn during various stages of puberty rites to prepare young people for their initiation into adulthood. The young lovers assume different animal shapes and flirt with each other in the gestures and sounds of the animals whose masks they wear.

Paintings such as this recall us to our own "human animal" nature, reminding us that we, too, are an animal species and that our social roles are our masks. Indeed, when wearing an animal mask, the human removes him- or herself from the artifices of "civilization" or "culture" and comes into closer contact with his or her species' nature and spiritual source.

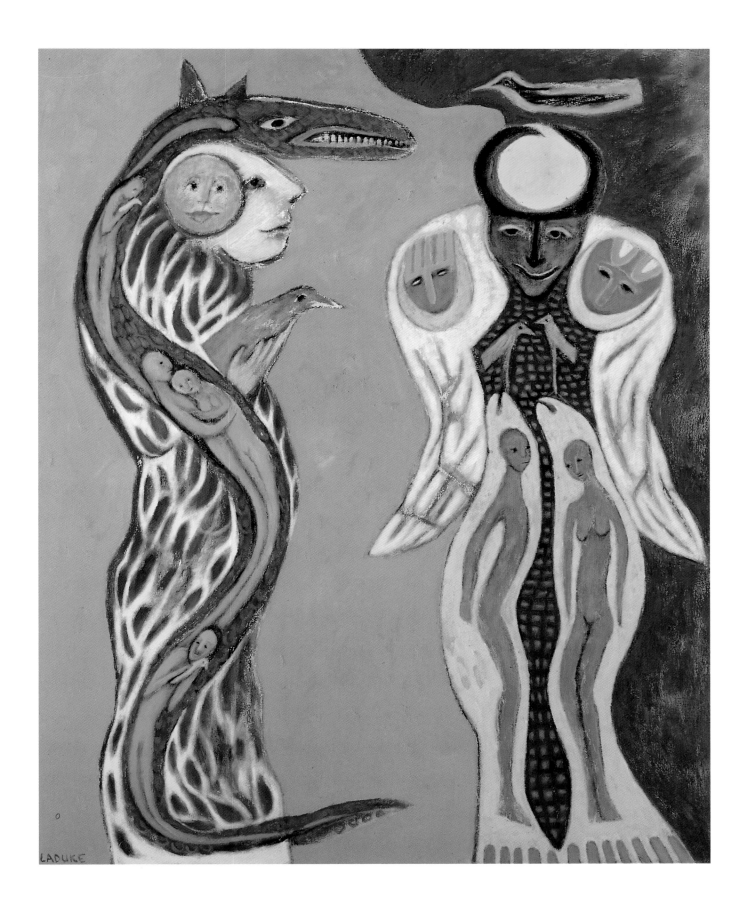

▶

Australia: Aboriginal Love-Magic 1979, acrylic, 54 x 50 in.

This painting functions both as a ritual and as a magic potion. It weaves a spell in which the male and female are attracted to each other, first as spirits and then as physical beings. The spirits spin around in a spiral, and the energies generated by the vortex of the magical art work create the love-magic. Paintings such as those that inspired this work are actually made to cast a magic spell.

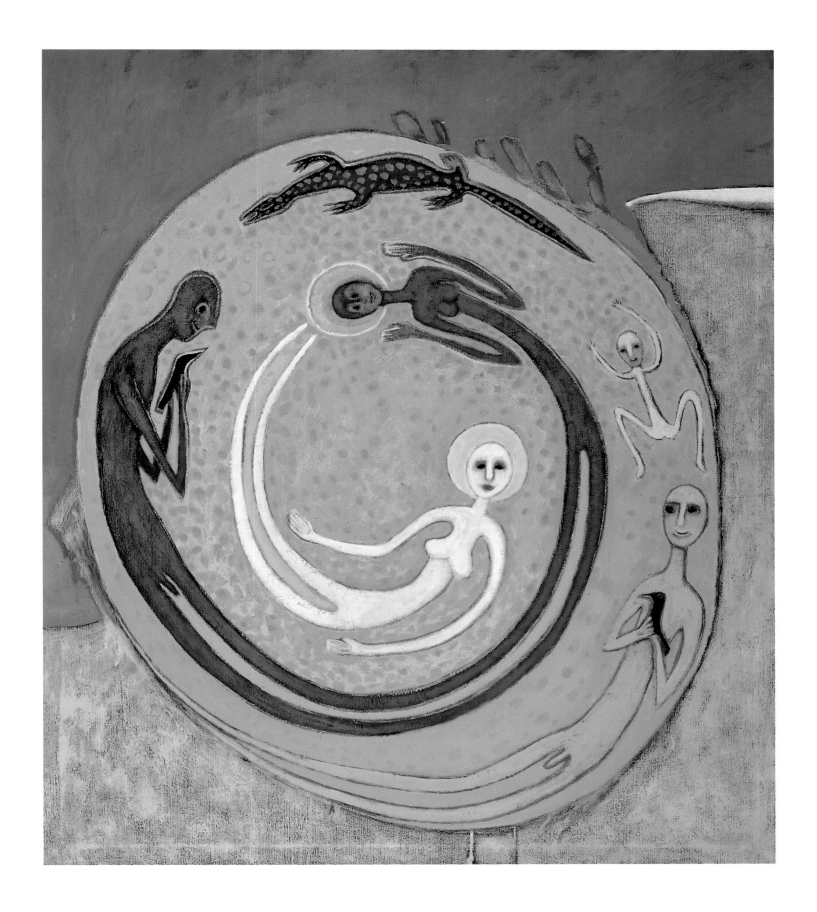

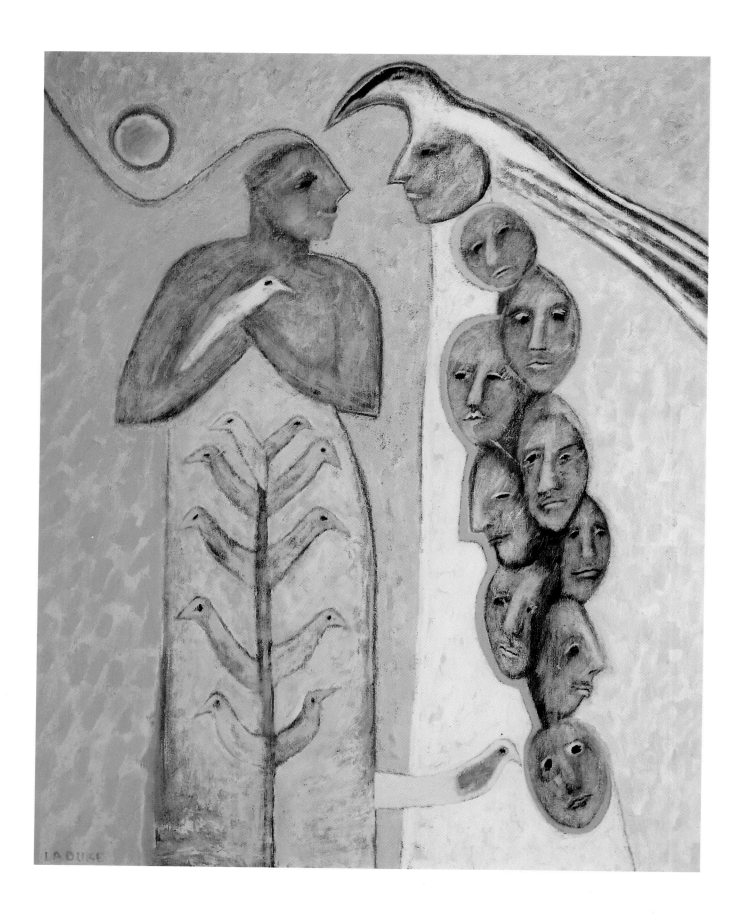

◀

Borneo: Iban Marriage 1980, acrylic, 68 x 54 in.

In the past the Iban marriage ceremony in Borneo required the groom to kill an enemy and present his head to the bride as a symbol of his manhood. The skull would be honored and kept in the family compound. Here the groom has many heads within him, symbolizing his love for his bride. He is obviously a skillful warrior. The spirits he displays to his bride will be honored and fed rice. In this way they will be remembered throughout the generations.

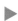

Africa: Night Journey 1986, acrylic, 72 x 68 in.

Great lizard shapes vibrate with color and energy as thousands of male and female humans and lizards seek each other in a nocturnal cosmic mating dance. In LaDuke's interpretation, lizards and humans generate each other, and both are connected to the spirit of the serpent and to snake power.

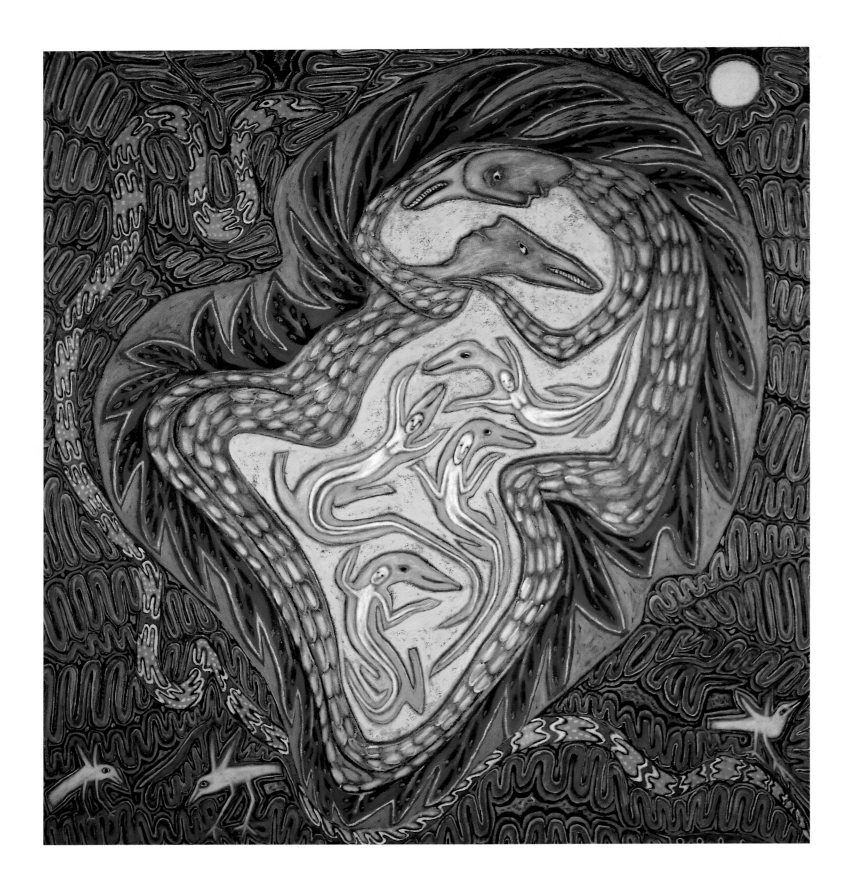

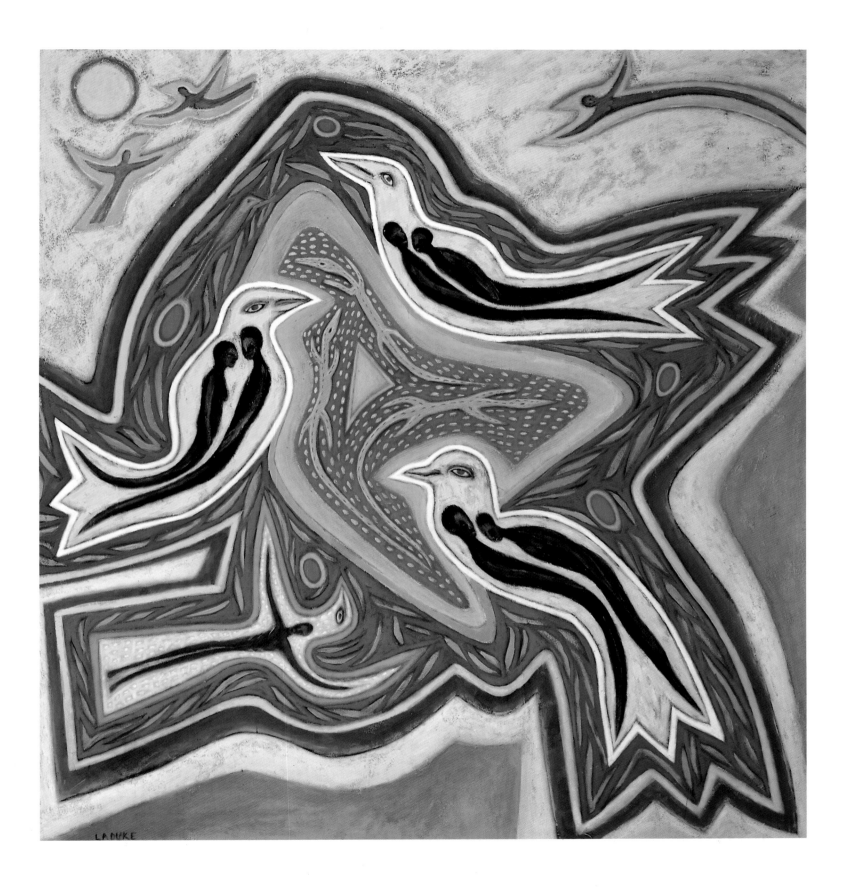

◀

Africa: Mandala 1991, acrylic, 72 x 68 in.

Male and female forms float toward each other on a sensual ray of solar light that is as large as the universe and is propelled by angelic bird-beings, who guide humans along the paths of the cosmic mandala of life and love.

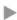

Africa: The Oba's Dream 1991, acrylic, 32 x 44 in.

Since Obas can have as many wives as they can support (including very young wives), LaDuke has envisaged the Oba's dream as one supporting fertility, both in the present and in the future. Here the Oba's arms, like those of the Great Mothers and healers in LaDuke's oeuvre, become spirit-birds, as do his words and his thoughts. The large, golden spirit-birds are the dreams of wives to come to him in the future, perhaps sent via spirit messengers, also in bird form. The Oba and his prolific capacity for the support of procreation is seen as a force of nature that transmutes desire into fecundity. Here the artist does not make a westerner's comment on polygamy. Rather, she tries to look upon polygamy with the eyes of an African Oba, who is wedded both to his wives and to the fertility of the Earth, as well as to ensuring the continuation of his tribal heritage for many generations to come.

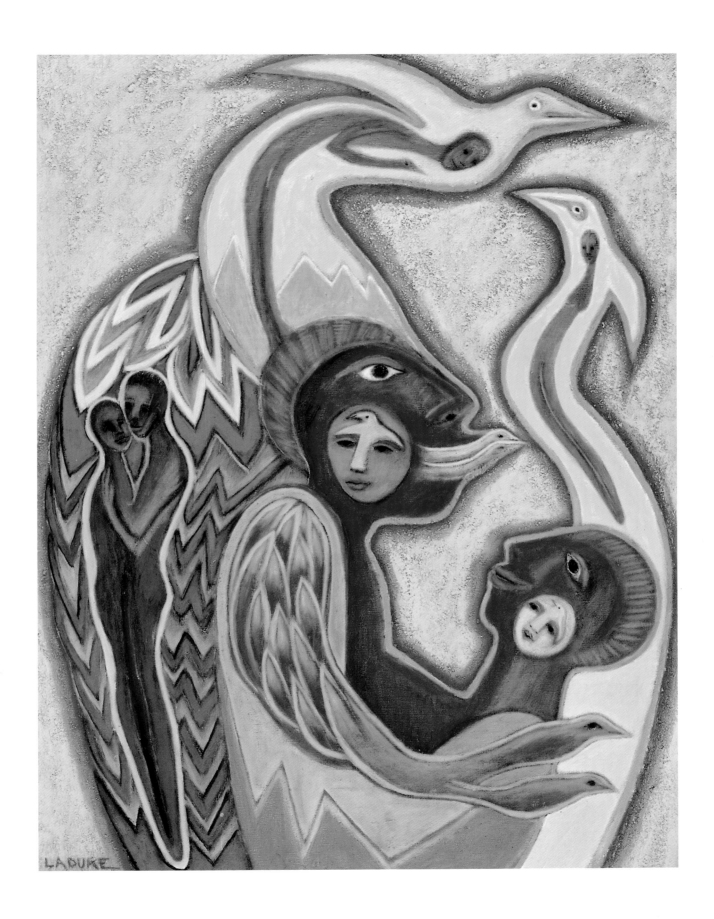

5 earth survival

In this sequence of works, Betty LaDuke's ecofeminist vision is poetically rendered as we see the intimate relationship between humans and the Earth, reminding us that, in the words of a popular chant: "The Earth is our Mother; we must take care of her."

Earth survival is intimately and reciprocally connected to human survival. As we perceive human laborers, often exploited both economically and politically, embodying the shapes of the land they till, the mountains that surround them, and as we see their bodies pulsating to the rhythms of the music in the souls of the animals and in the beat of the rushing waters, we come to envision the Earth as well as the laborer. Earth survival is connected to a political and spiritual vision that comprehends the ways in which the Earth is threatened when humans are endangered (wars, natural disasters, and so on) and vice versa. The fate of humanity is thus linked to the fate of the Earth in multiple ways. The artist celebrates the joyous, life-giving energies of the natural cycles, and empathizes with the burdens placed on the land and the people by the demands of Western monoculture and development in their exploitation of all natural resources and their indifference to the sacredness of the Earth and its peoples.

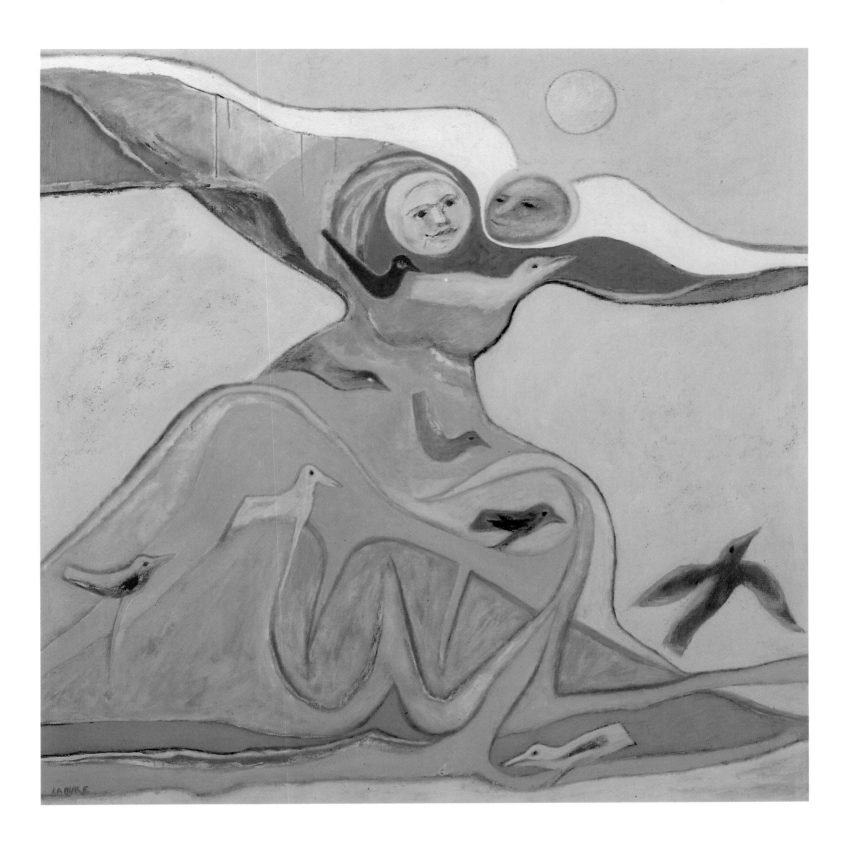

◀

Oregon: Ocean Sunrise 1978, acrylic, 72 x 68 in.

In this visionary interpretation of the mother goddess's presence on the Pacific Coast as it washes over the Oregon shore, a powerful woman rises and is embraced by a sea gull (her husband / lover). Her vast lap contains outlines of the mountains, whose female forms are now identified with the body of the Great Mother and her spirit (bird) children. This Great Mother is a metaphor for human mothers as well as for Mother Earth. The fertility of all life, whether life in the water or on the land, human or non-human, is sustained by the power of love.

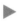

India: Spring Ritual 1973, acrylic, 72 x 68 in.

Plowing the soil in order to prepare the land for planting is, as the title of this painting indicates, a spring ritual. It is done with a sense of the sacred nature of the work performed and of all the participants, animal, human, and invisible. The power of the oxen is rendered via the scale in which they appear, as bulwarks of force in size and shape, relative to the human figures in the landscape. Indeed, the oxen merge with the land so intimately that its colorful fields can be seen shining through their bodies. During the spring ritual, a true harmony with nature is achieved.

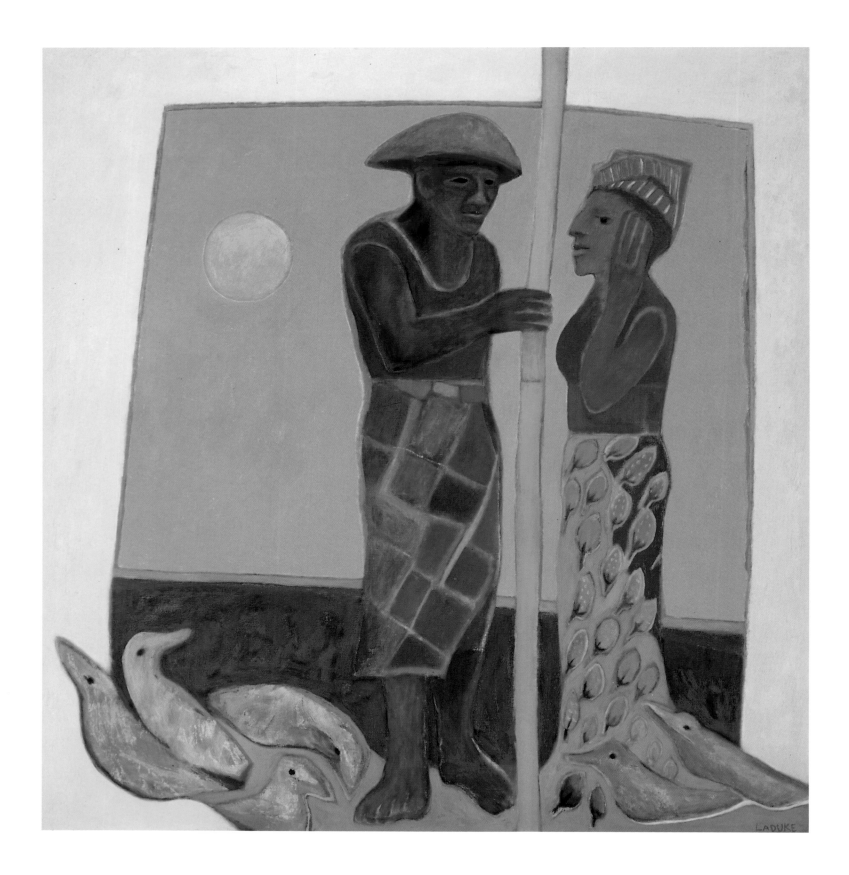

◀

Bali: Sunset 1974, acrylic, 72 x 68 in.

A farmer and his wife survey their planted rice field and think about their future harvest. The bamboo pole, like a tree of life, seems to rise straight up to the sky, making this scene a painting within a painting. Thus, the farmer and his wife, whose harvest shines through their skirts (his: colorful fields; hers: seeds and rice) represent but a moment in the eternal cycle of the fertile intercourse between humans and the land. These interactions are a kind of wedding of human energy to the Earth's energy.

The symbolism of sunset is important; it is during the night, or in the darkness, that the seeds of life will take root, be nourished, and begin to grow. The setting sun, like the scene within the painting, is only one phase within a larger cycle of light.

Guatemala: Masked Volcano 1978, acrylic, 68 x 54 in.

The masked volcano has a precise significance here. In LaDuke's visual metaphor, the victims are like fallen birds, and their human forms come together within the shape of the volcano. This image of unity in diversity shows the beauty of the people whose cultures are threatened by the mainstream. For the victims, the stars are filled not with light but with blood.

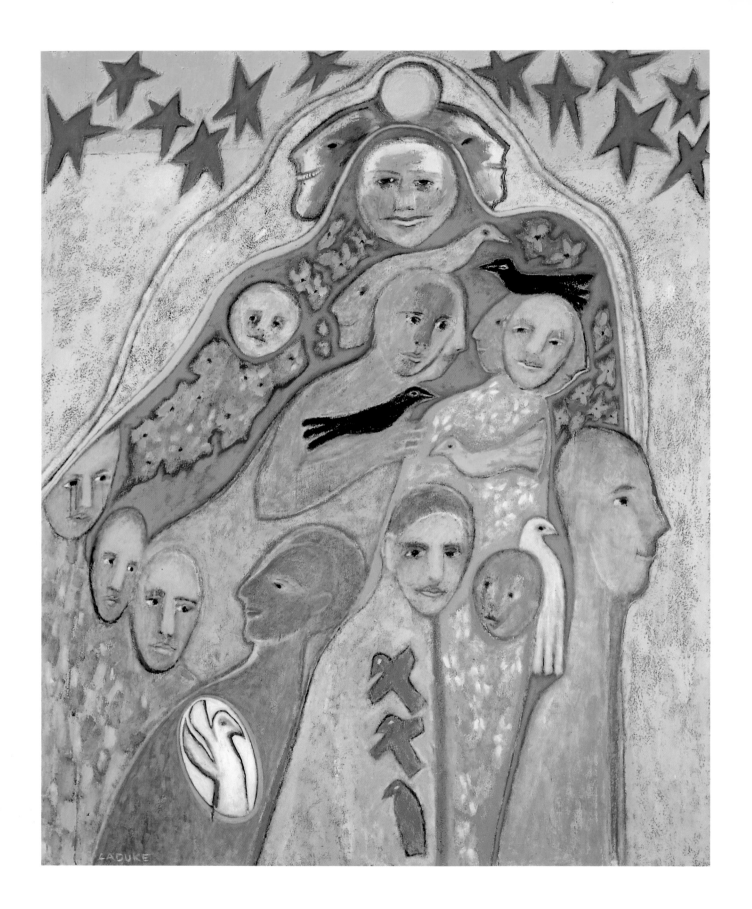

◀

Peru: Earth Mother 1983, acrylic, 72 x 68 in.

The triple-faced Corn Mother is presented in pyramidal form. The sacred energies of the pyramid structure govern the flow of the life force from the mother's lap to the moist earth below her, which, in turn, gives rise to the life-sustaining corn. LaDuke's visionary abilities enable us to imagine the all-nurturing Earth Mother, whose spiritual power sustains all living things.

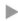

Egypt: Along the Nile 1988, acrylic, 72 x 68 in.

While patriarchal politics cause war to devastate the land, Egyptian mothers live in harmony with the Nile River and with its annual floods and soil deposits, which determine the growth of the crops. These market women with their children inspired the artist to remind us of how both human nutrition and nurturance are dependent upon the sacred waters, without which life could not exist. LaDuke sharply contrasts this life-giving cycle with the flames from the many wars that have destroyed the land, waters, and crops upon which life depends.

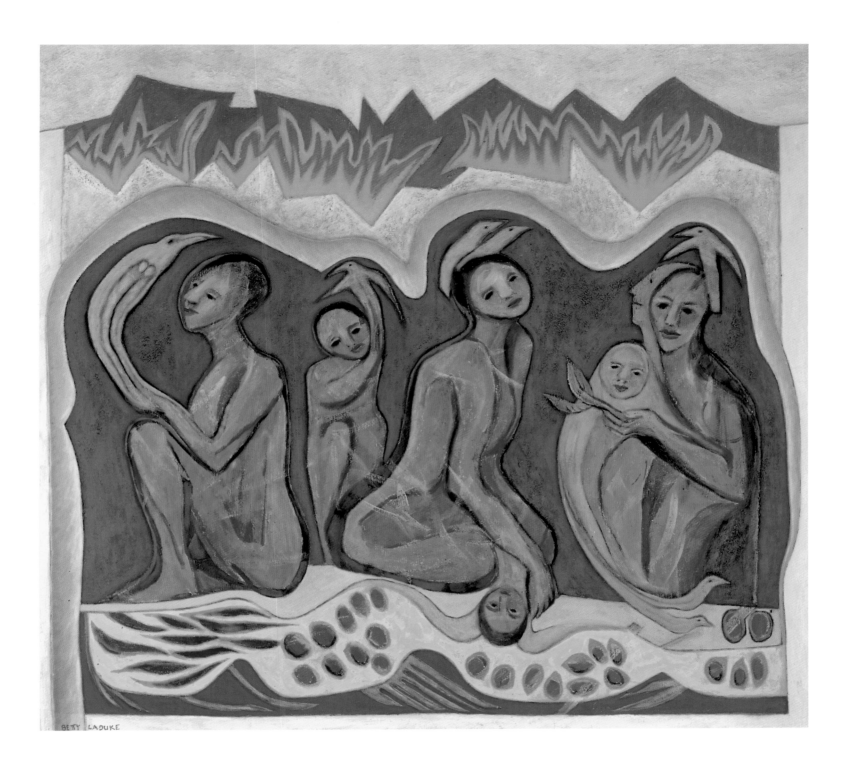

BETTY LADUKE

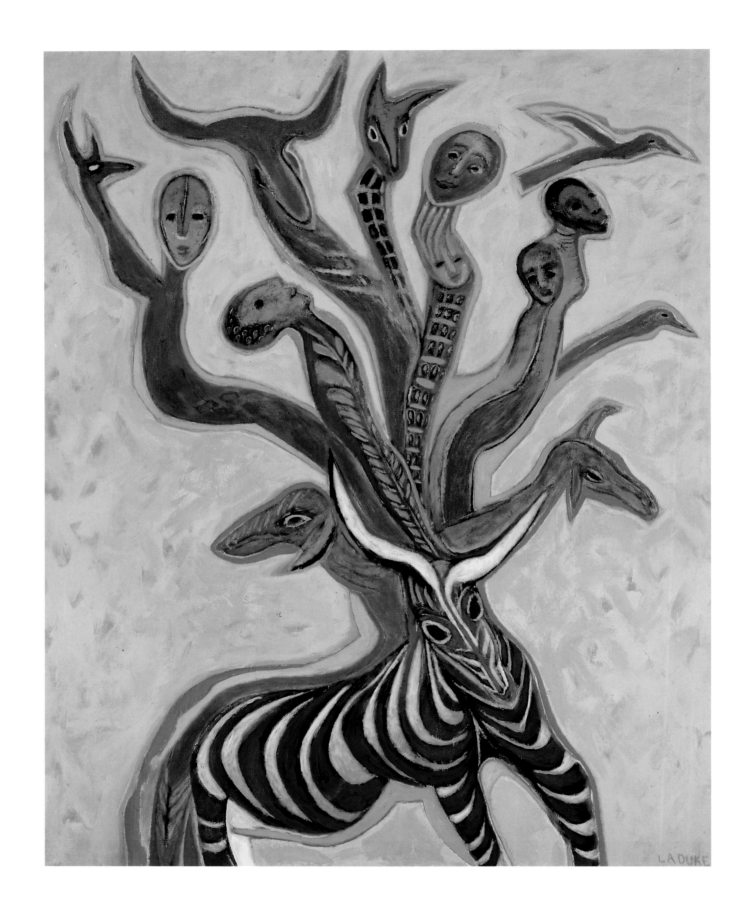

◄

Africa: Zebra Tree of Life 1988, acrylic, 68 x 54 in.

The merging between the Masai people and their animals is so complete that any one of them may become a tree of life for the others. The Masai tribe is here depicted as the branches of the zebra tree of life, which extends into eternity. These branches are both animal and human; all are of equal importance and all are relations, branches of the lineage of an extended family. Both animal and human branches / tribes / offspring bear the markings of their animal (in this case zebra, but also human animal) origin. We all stem from the same root and share an animal nature.

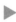

Africa: On the Farm 1990, acrylic, 72 x 68 in.

Women and men work the millet fields together, and their movements soon embody the shape of the crook of the tools they work with. In this shape we perceive simultaneously the burden of the arduous physical labor they perform and the agility of their lithe bodies, whose movements undulate with the rhythms of the Earth and the dance of creation.

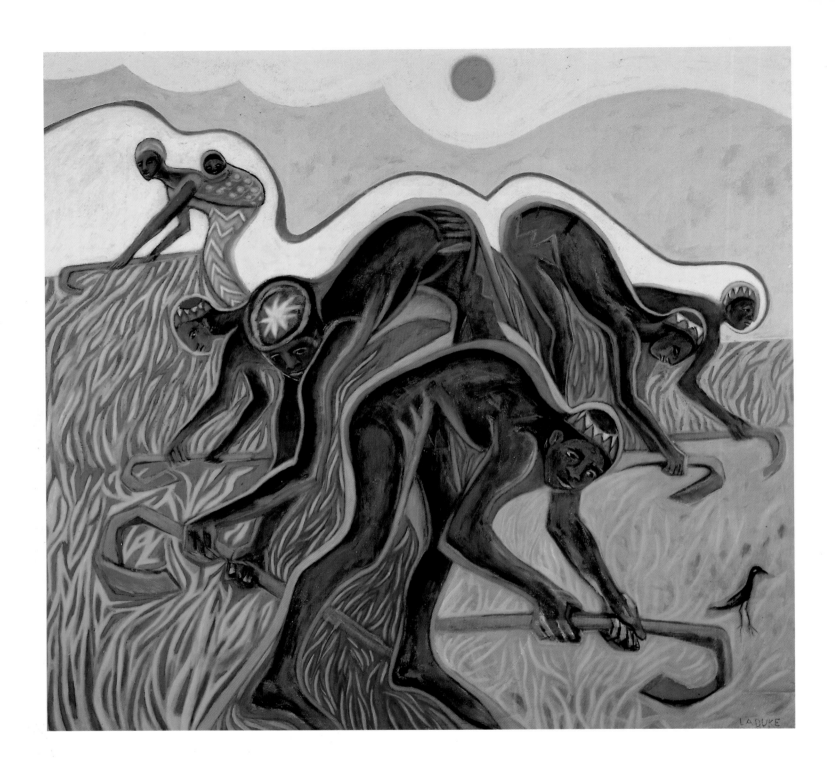

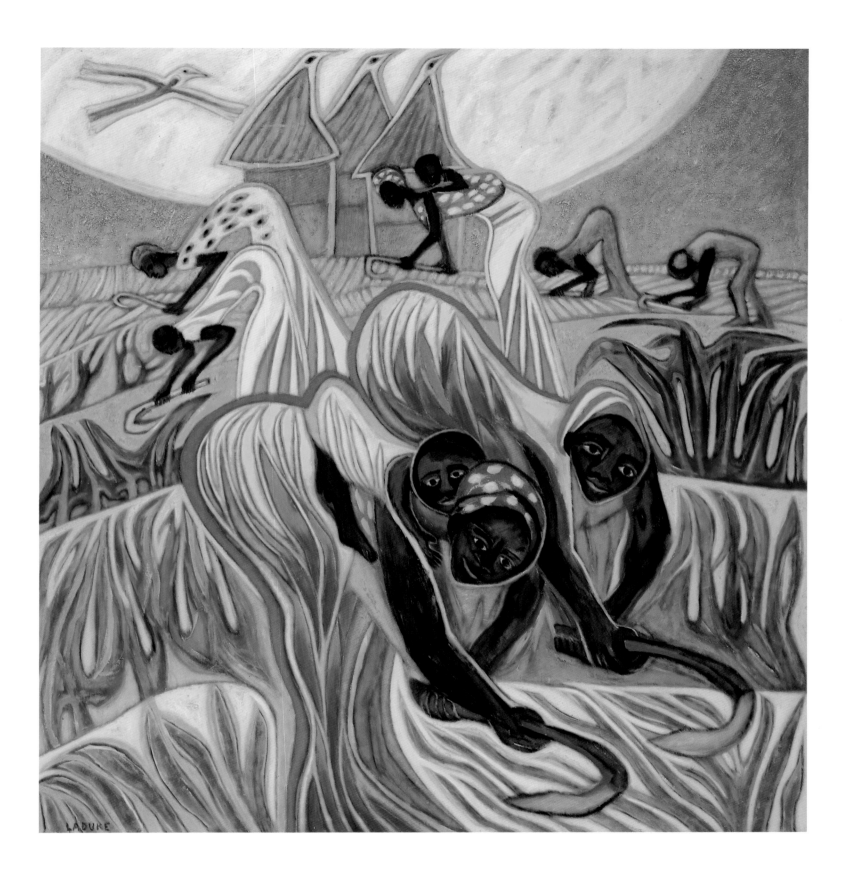

◀

Africa: Millet Rhythms 1992, acrylic, 72 x 68 in.

Women work the land carrying their children on their backs. Their bodies take on the curvature of the
mountains as the energies of the Earth course through their legs, attuning them to the Earth Mother,
giving them the strength to carry on. All is colorful and light-filled when humans come so close to their
source of nourishment. Although this physical labor is intensive, the light of spirit that inundates the
atmosphere enables them to continue.

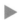

Africa: Horn Play 1992, acrylic, 68 x 54 in.

This lyrical work is like an ode to the music made by the joyful animals whose horns dance and sing as
they romp playfully in the fields. Even the young herder is captivated by the rhythms of this animal
music. Distinctive light auras emanate from the animals, signifying that their horn play produces a
spiritual vibration that palpably influences the atmosphere.

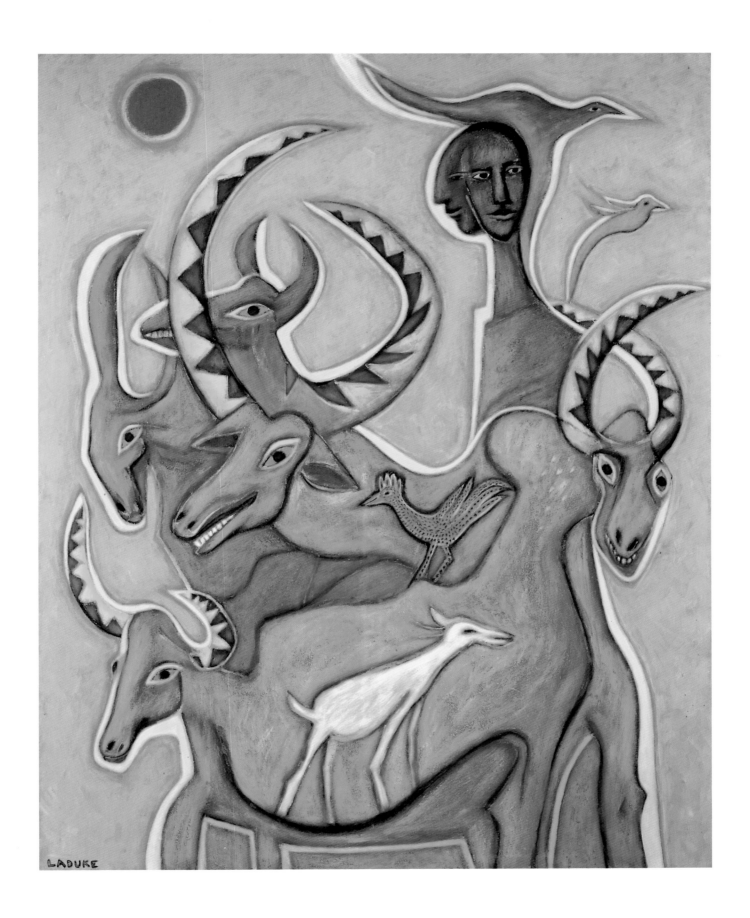

markets: change and interchange

At the marketplace we are able to observe the subtle ways in which humans exchange energy. Through the artist's eyes, we see how women selling their wares at the market identify their produce with their offspring and extend to both nurturance and loving care. It is in the exchange of animals and vegetables for a livelihood that humans ultimately come to understand the multiple ways in which other species sustain their lives. In the market they develop a sense of both ecology and economy. Spiritual transformations are also occasioned by the intimate relationship that the market fosters.

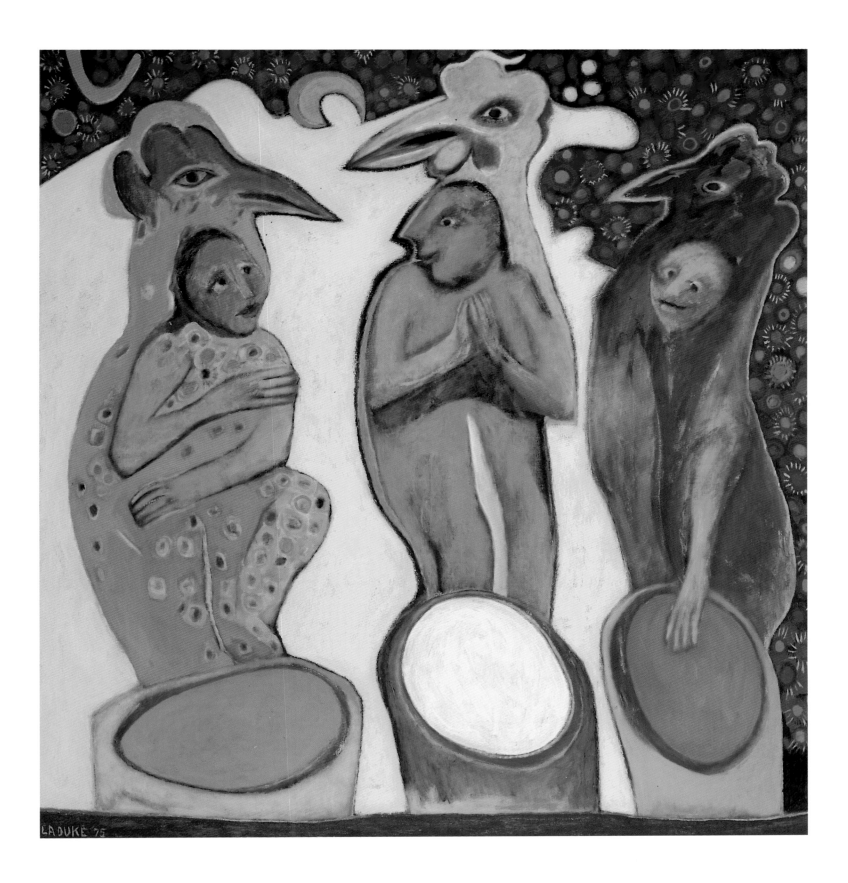

Sumatra: Chicken Metamorphosis 1975, acrylic, 72 x 68 in.

LaDuke's radar vision perceives the subtle ways in which our labor transforms us. Here women in the marketplace who sit patiently hour upon hour selling their chickens seem to metamorphose into the chickens they are selling; in some intangible way the chicken spirit overtakes them. This, however, is neither humorous nor degrading. In the artist's eyes, humble animals and humble humans are both sacred and vital to the sustenance of life.

Sulawesi: Male Metamorphosis 1981, acrylic, 72 x 68 in.

In Sulawesi, Indonesia, males raise roosters for cock fights. Identifying closely with the cocks, who "strut their stuff" macho style, these men soon appear to be strutting, and their spirits take on the characteristics of the roosters. This painting is a humorous comment on the bravado of those whose life energies are invested in strutting and fighting.

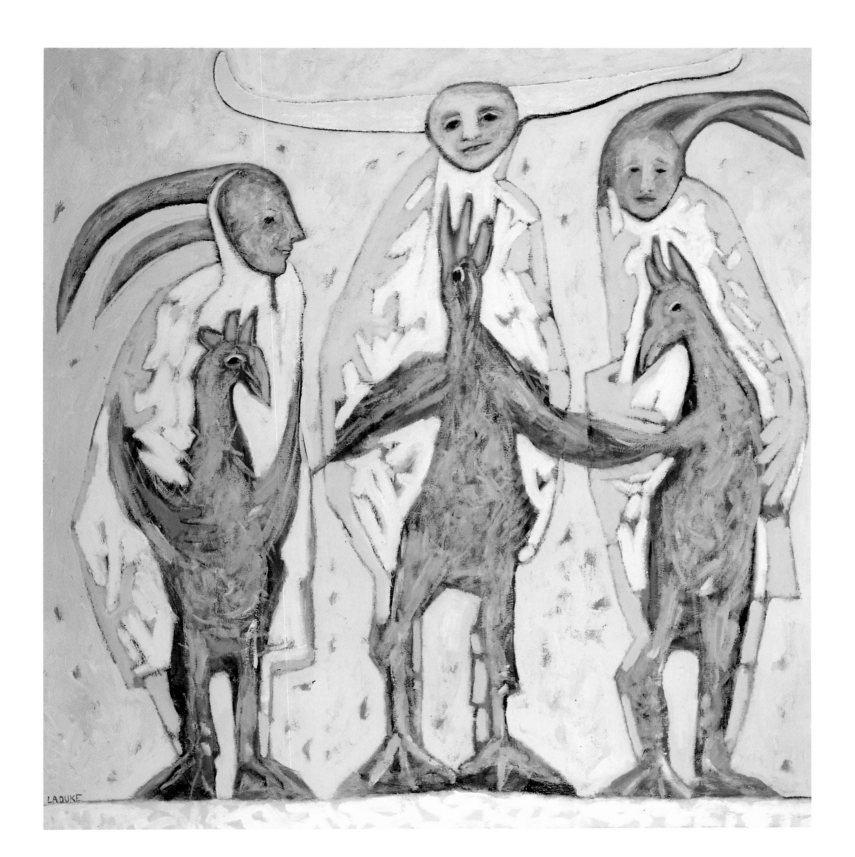

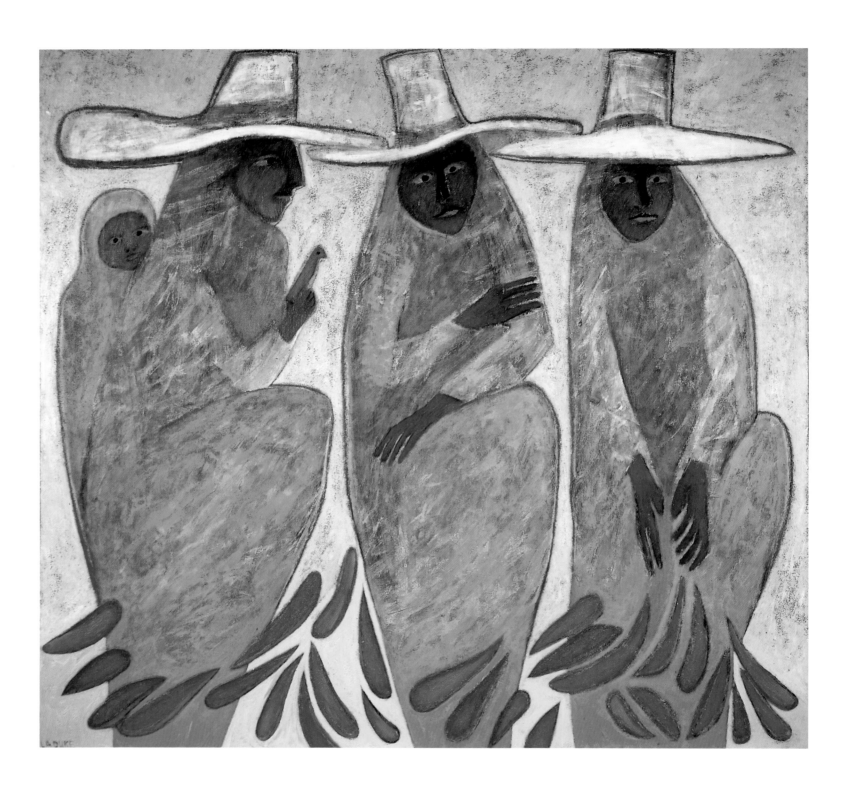

◄

Peru: Chili Vendors 1983, acrylic, 72 x 68 in.

These women selling chili peppers in the market sit beneath broad-brimmed hats in a timeless setting that has no horizon. They have made the fruits of the Earth available for others at the marketplace since time immemorial. Even the chili peppers seem to float freely through time. The solidity of these women suggests their eternal presence, linking us to the Earth's productivity in perpetuity.

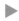

Africa: Bird Women, Carriers of the Dream 1986, acrylic, 72 x 68 in.

In Africa women produce and sell the bulk of the food. In the marketplace they sit for long hours selling their produce. Elderly women are associated with mythical birds that carry the dreams and messages of the people. These messages and dreams are carried in a gourd shape, just as are the foods that are for sale. Gourds and wombs gestate the life forms that eventually sustain and then become carriers of dreams.

Women are venerated as bearers of both material and spiritual produce. Here the head wrappings become animated and share the birds' spiritual message with both human and nonhuman listeners.

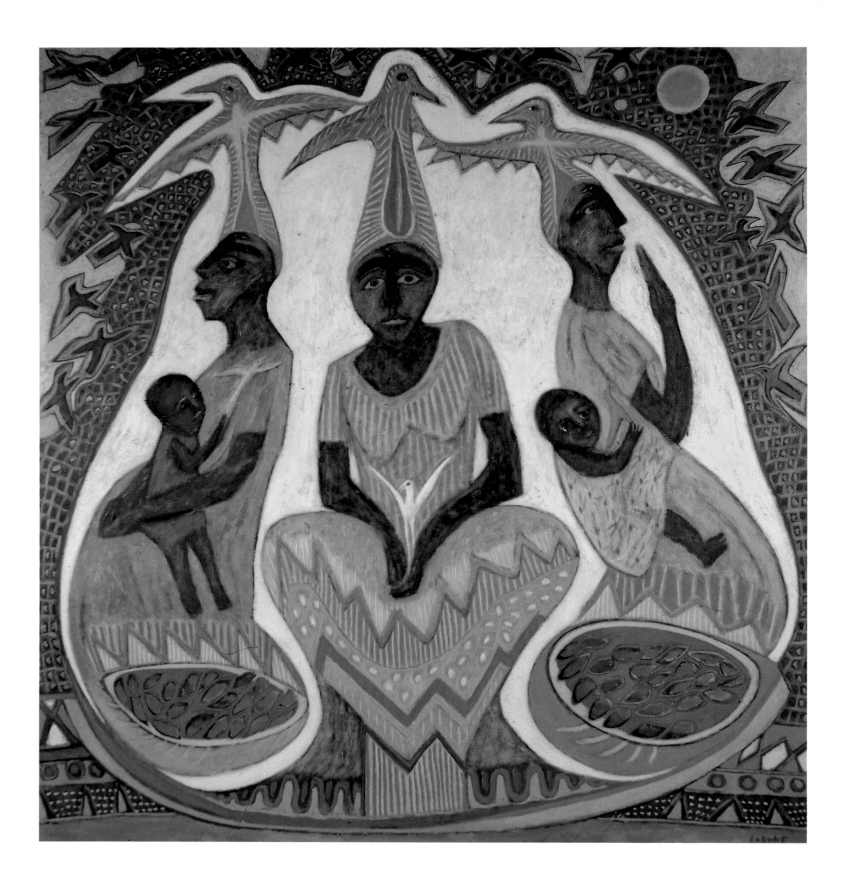

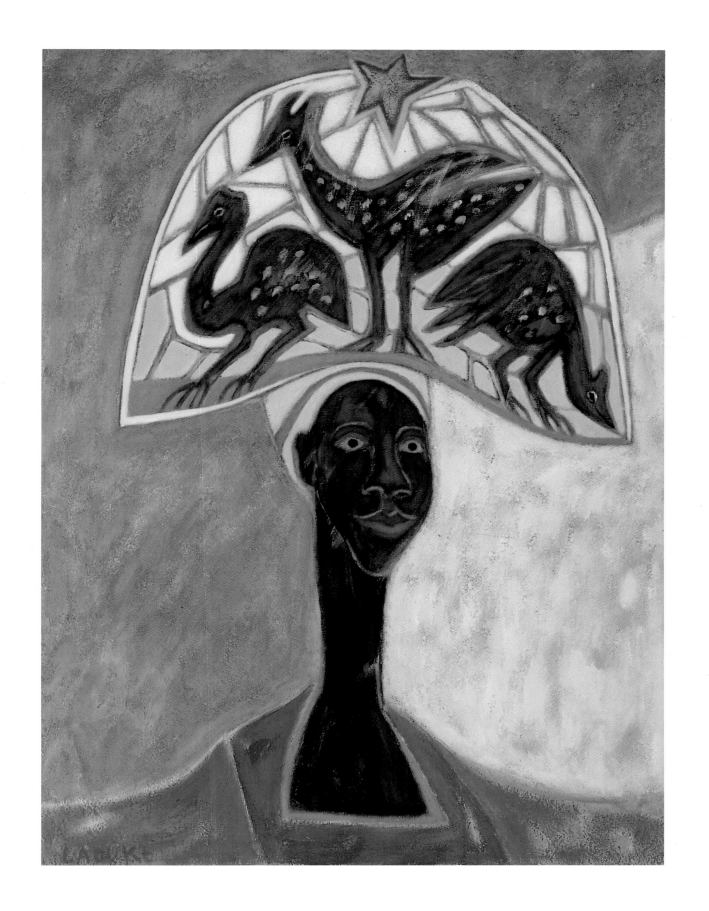

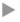

Africa: Market Day 1990, acrylic, 44 x 32 in.

A young girl with a basket of chickens on her head sets off for the market. LaDuke's iconography permits us to read this image in two ways. On the one hand, this girl is literally carrying a basket of chickens on her head. On the other hand, crowned as they are by the star, this is also her dream of the fertility of the chickens. Their bodies are rich with seeds of future births, so that market day can actually be seen as an enhancement of all fertility rituals.

Africa: Market Day Dreams 1992, acrylic, 72 x 68 in.

These African market women might seem to be earthbound, but to those with second sight it is evident that Earth energies soar through their bodies and are transformed into thoughts of a spiritual nature. These thoughts and visions, symbolized by the birds over their eyes, stretch out to the universe and the air and ultimately fly off into the deepest spiritual realms.

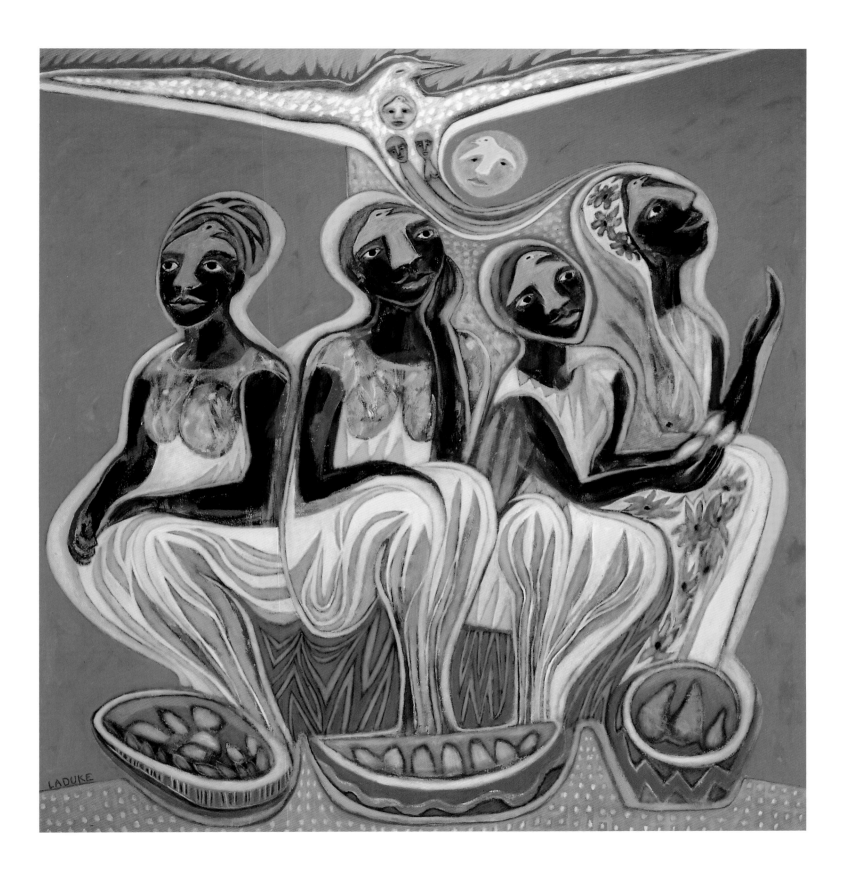

▶

Africa: Fish 1992, acrylic, 68 x 54 in.

The fish with real cowrie shells behind the head of the market woman looks down upon the fish she is cooking. After many hours of getting to know them, the fish the woman sells from the stove at night become like people for her. The reciprocity of people eating fish and fish eating people is also evident in this work. Water is the common element we share, like the membrane through which our bodies nurture each other. We are made of one another; we human beings have passed through the fish stage in our development, and we are one with the fish we eat. Commerce, seen in this way, is that part of the life cycle in which human and animal energies are interchanged. It places a numerical value on the products that are invaluable to us. LaDuke reminds us of their intrinsic value in the great chain of being.

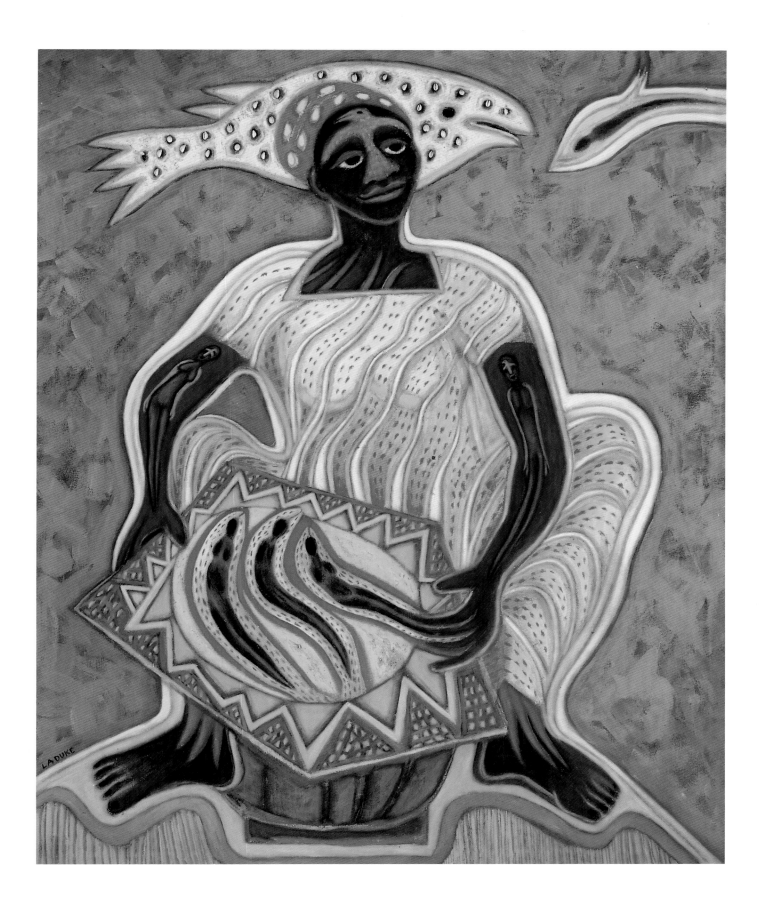

sacred sites, shrines, and temples

Around the world, humble people observe manifestations attesting to the presence of spirits in their homes, in their communities, and at sacred sites in nature. In this section, LaDuke celebrates the way in which spiritual power manifests and is recognized, attracted, and communicated with in a variety of cultures. While we in the West do not have (for the most part) shrines or spirit houses in our homes, around the world it is considered natural to honor deceased ancestors, unborn children, and deities at home. The rites performed by ordinary citizens in communion with the spirits are as effective as those performed by ordained clergy. Giving offerings to spirits in order to feed them or to placate them is done not only in public but also in private, as people recognize that the spirit is real.

◄

India: Hindu Temple 1972, acrylic, 72 x 68 in.

A tall, phallic-shaped stone known as a lingam is found on the pedestal at the center of a Hindu temple. As a symbol of the universal creative energy, the lingam is anointed with oil, encircled with garlands of flowers, and worshipped by all. Here LaDuke envisages the multitudes who have been energized and inspired by this form of worship.

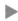

Sri Lanka: Cow on a Moonstone 1974, acrylic, 72 x 68 in.

At the entry to the Hindu temple one can find a large semicircular stone on which the sacred Brahman cow is carved in a repeated border design. Amazingly, the multitudes who have stepped on this stone for centuries have not worn down the carved cow's rhythmic movement. In this painting, LaDuke portrays the faces of the worshippers within the cow's interior. The miracle of the cow's image remaining intact manifests the presence of the divine at this temple.

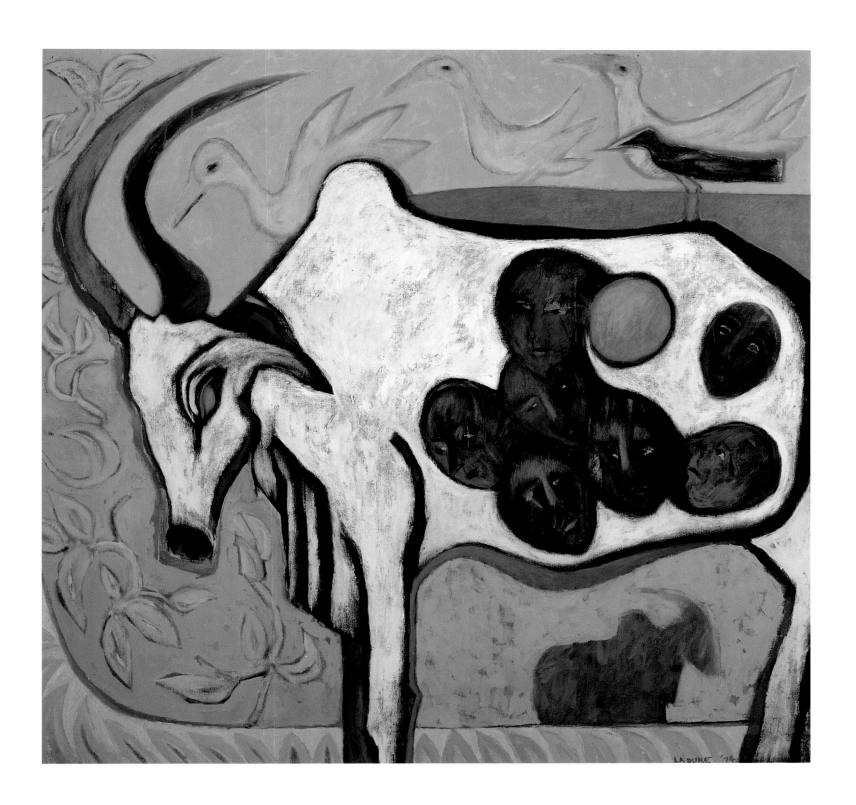

▶

Sri Lanka: Buddhist Temple 1974, acrylic, 72 x 68 in.

In the compassionate relationship between the Buddha and a bird, depicted along with scenes from the life of the Buddha on this temple wall, the bird represents an incarnation of the divine spirit. The other bird, the one that alights on the Buddha's arm, painted in the style of the bird-spirits-as-dreams-and-messengers in other paintings, reminds us that real birds, dream birds, and spirit-messenger birds are all equally sacred to the "enlightened one." Here, music (the pipe being played), too, is an expression of Buddha energy, and it sings directly to the souls of the animals. In a similar way, visual art, particularly temple art (the art about temple art), speaks directly to our spiritual nature. The lush, richly painted surfaces literally vibrate with the energies of the awesomeness of all creation, symbolized by the Buddha nature alive in all creatures.

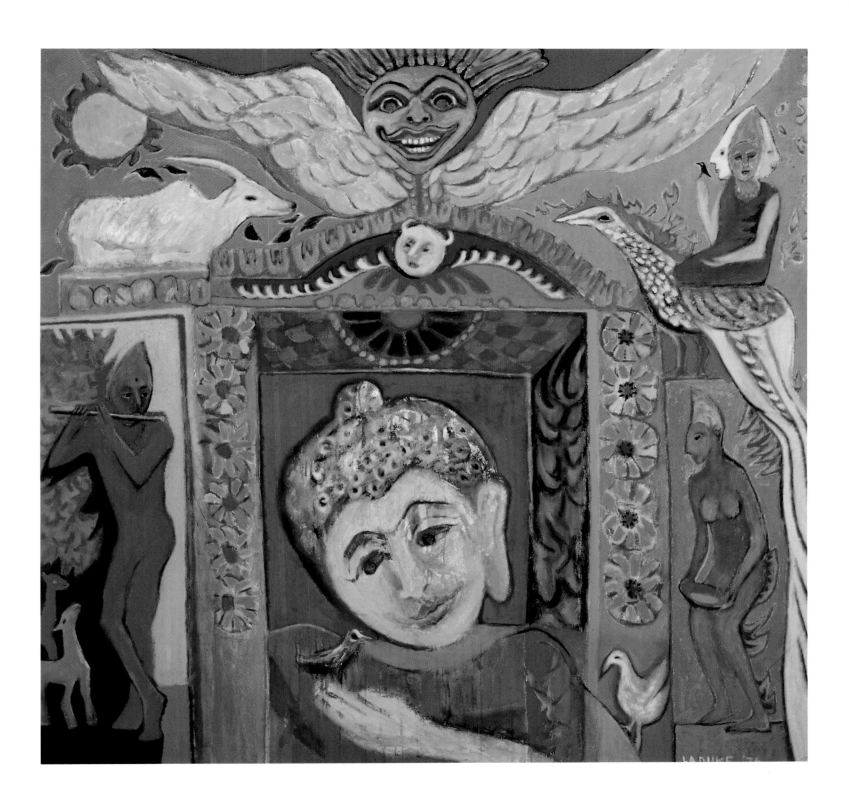

Thailand: Spirit House 1974, acrylic, 44 x 32 in.

In Thailand a little spirit house sits on posts outside one's home in order to protect the family from evil spirits. In this work the artist became the mother guardian of a spirit house in order to protect her son, Jason. Just as the spirit house fulfills the function of spiritual protection, so this painting serves as a spirit house for the child for whom it was made.

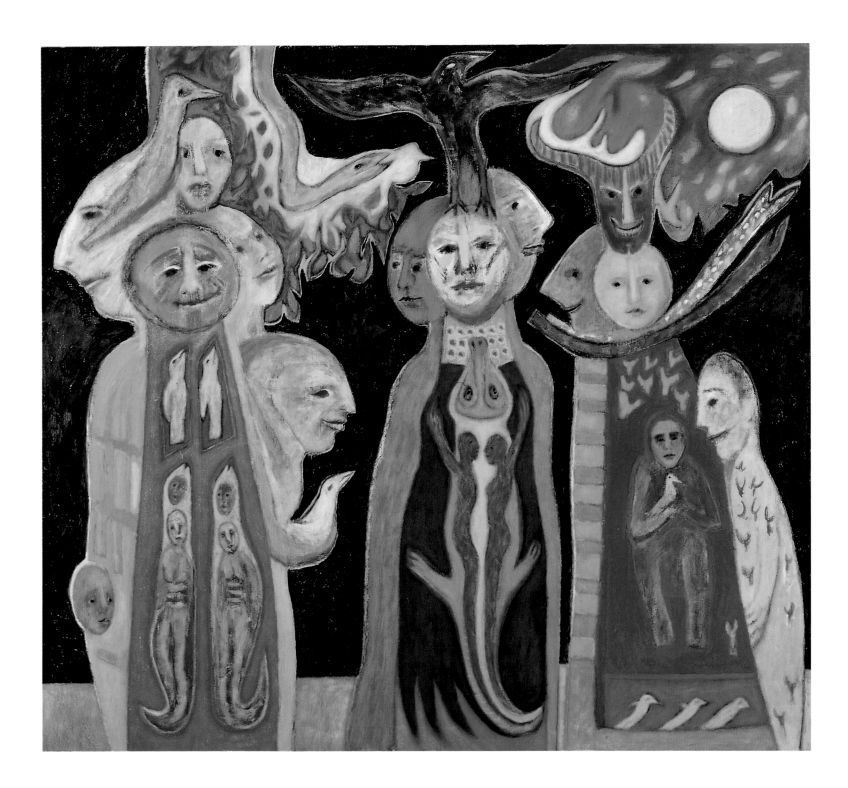

◀

Papua New Guinea: Totems 1979, acrylic, 72 x 68 in.

These are ancestor totems that mark the site where the ancestors in one's family, tribe, or lineage *still live* in the form of spirits. The totem, like a tree of life, keeps the spirits of the lineage alive in the spirit world, and its presence keeps them in constant spiritual communion with their descendants, now incarnated in the material realm, on the Earth plane.

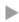

Mexico: Easter Journey 1978, acrylic, 68 x 54 in.

The Virgin and Christ, female and male, transform the cross of crucifixion into a spiritual crossroads. For it is at the point of intersection of the horizontal and the vertical, the material and the spiritual, that miracles can occur, and that spirit can manifest on Earth. The symbols of stars and birds in LaDuke's work remind us that all earthly things are also spiritual, and that we, too, come from the stars.

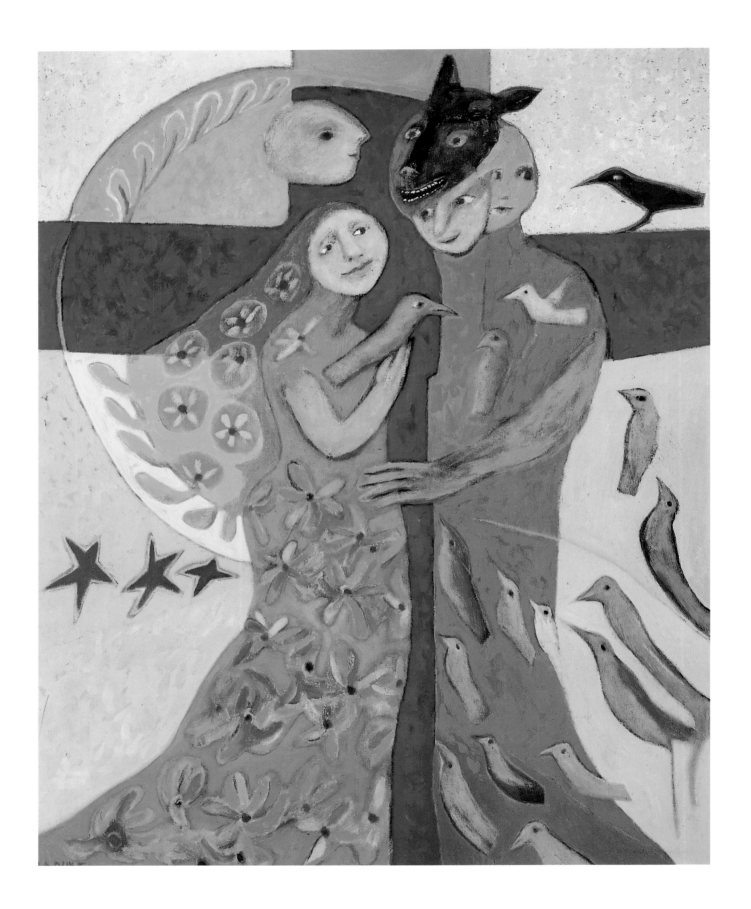

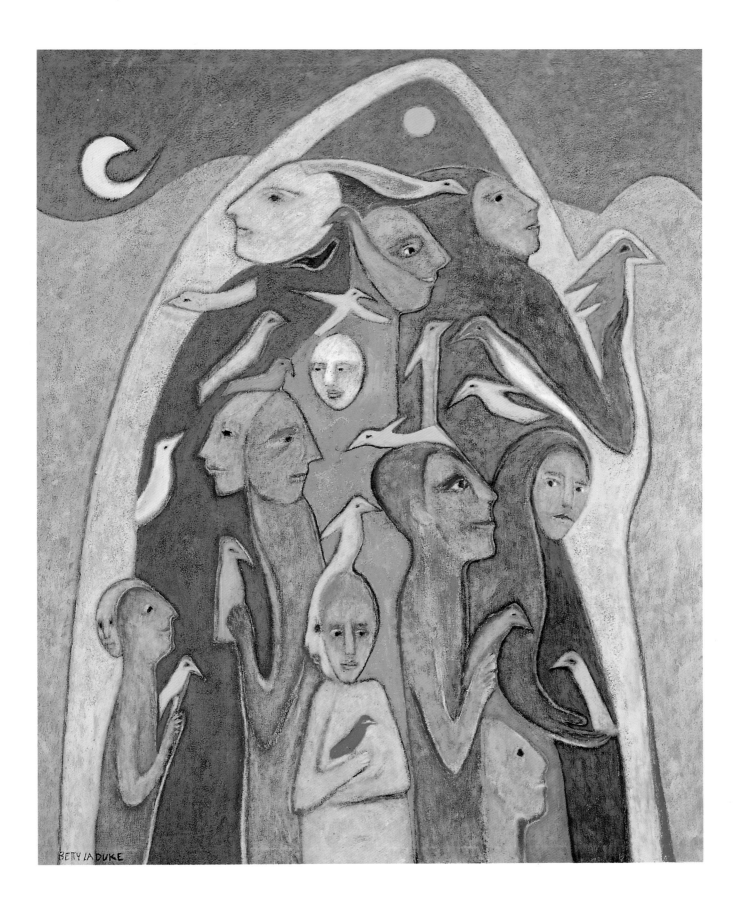

◄

Peru: Machu Picchu Revisited 1981, acrylic, 68 x 54 in.

Inspired by the journey she made to Machu Picchu in 1981, the artist honors the spirits of the people from the Andean culture of the altiplano, who for centuries have been making pilgrimages to sacred cities such as Machu Picchu, located on the peaks of their majestic mountains.

Today indigenous peoples are keeping alive not only their ancient history, preserved at sites such as these, but also the spirits of their ancestors, who inhabit their sacred mountain homes as their final resting place. Now the spirits are awakening, as indigenous peoples as well as contemporary seekers journey to these mountain sites in search of the ancient wisdom. On their vision quests they learn, through experiencing shamanic, ecstatic states at high altitudes, that the Earth is a living, intelligent being, and that she is speaking to us powerfully.

In this painting the spirit birds, like candle flames, alight upon the heads of the ancestors, causing them to look around and to rise to the full height of their spiritual being in their mountain home habitat. The quickening of the ancestral spirits within the mountain may produce the miracle that answers our prayers, in which we are so moved by the spirit and beauty of the mountain that we may yet relearn to move mountains (both literally and symbolically), and thereby change the course of our ecological and spiritual history.

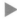

Africa: Ancestor Shrine 1989, acrylic, 72 x 68 in.

Ritual celebrations to honor the deceased ancestors are integral to the Dogon peoples of Mali. The past is always present. The sacrificial blood of animals returns to the earth to strengthen the bond of interdependence among all life forms.

8 healers

With the Western medicalization of most physical and even natural processes such as birth, we have forgotten that both in the past as well as presently in indigenous cultures, people may be healed of all sorts of ailments in a wide variety of natural ways. These approaches to healing are based on the knowledge acquired experientially and clairvoyantly that our bodies are energy fields, that they emit energetic auras and have vortices of energy called chakras, and that by balancing these vortices and fields healings can transpire. In many cultures, women have become the keepers of this knowledge.

In this type of balancing, the healer simply channels healing energy from the Earth and the cosmos through her or his own body and, via the laying on of hands, transfers this energy to the patient. Herbal cures are also effective natural methods of healing. Through the ingestion of sacred herbs, whose spirits enter our own, we are often guided toward knowledge obtained in an altered state of consciousness, which can lead us to take measures that will effect a healing.

When performed ceremonially, even art can rebalance a person's energies and realign the ailing person with the powers of the universe, so that his or her life will come into balance, thus eliminating the disease. Since a healer must seek the cause of the disease, she or he comes into contact with the aspects of negativity that we identify with the dark forces of the goddess of both life and death. In natural healing, the healer must see both the light and the dark aspects of the Great Mother's creation, and, like Kali, must learn both to create life and to destroy the powers of darkness.

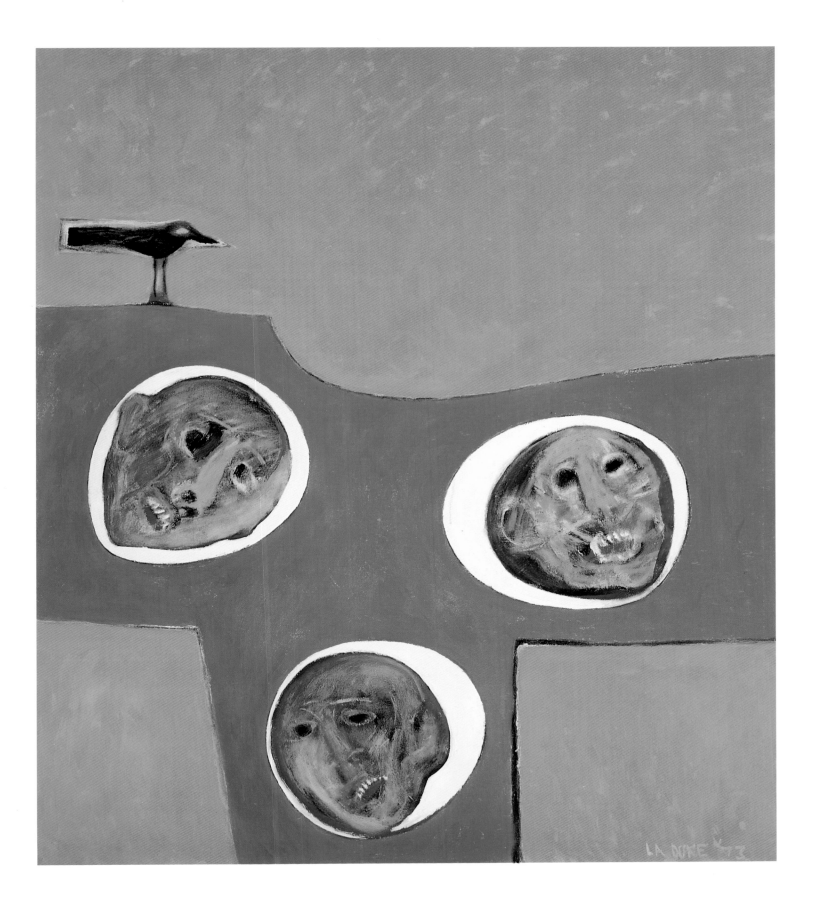

◀

India: Blind Seer 1974, acrylic, 68 x 54 in.

The pain and suffering on the faces of the blind prophets, who are storytellers and singers, arrest the attention of the artist. The seers' inner vision can warn us of future harm and can explain the events of the past so that we can take measures to turn the tide of destiny toward a more hopeful, less sorrowful tomorrow.

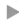

India: Homage to Kali 1974, acrylic, 72 x 68 in.

As both the preserver and destroyer of life, Kali is revered as well as feared. She wears a necklace of skulls, signifying her bloodthirsty aspect, and she wields the power of life and death over all things.

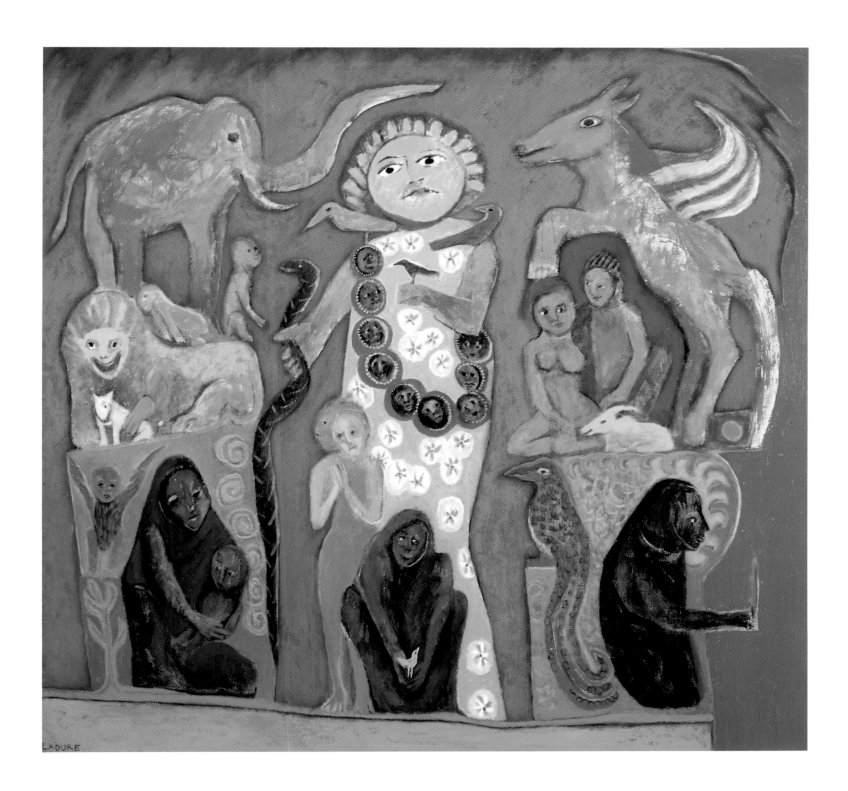

▶

Haiti: Voodoo Spirits 1984, acrylic, 72 x 68 in.

The participants in a voodoo ritual evoke the spirits of the ancestors, represented by spirit-birds that emerge from the faces placed totemically along the bodies of the women. Each female participant in the spiritual work carries the spirits of her lineage within her, and the ritual activates their presence.

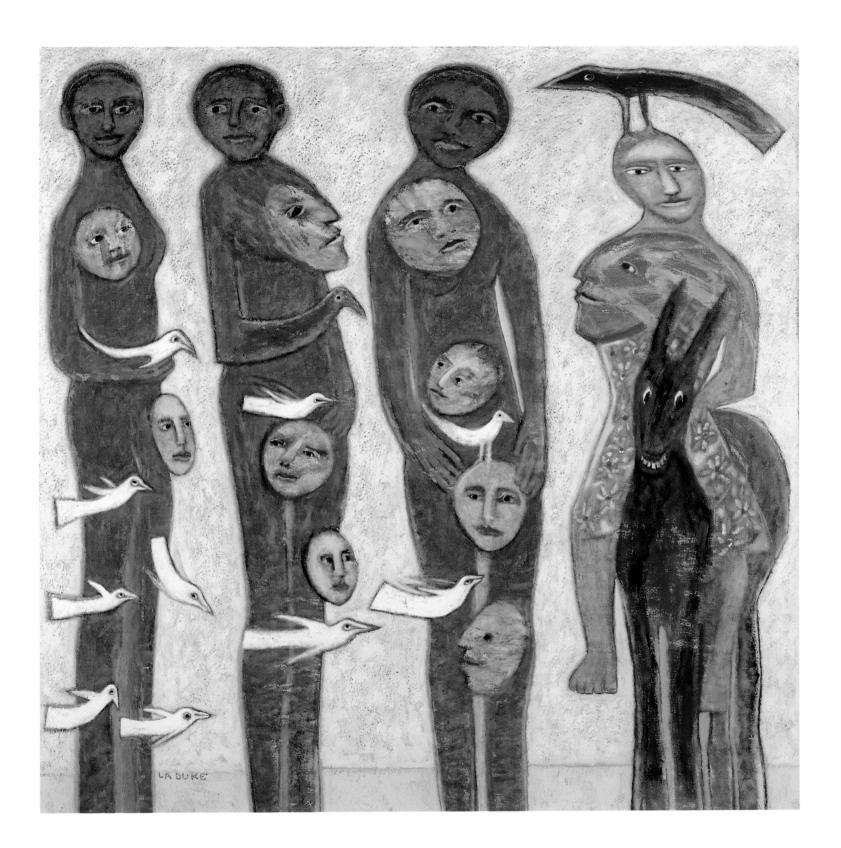

▶

Bolivia: Pachamama and the Magic Leaves 1985, acrylic, 44 x 32 in.

From pre-Columbian times to the present coca leaves have been used ritually by Bolivian women to ensure the fertility of the land and the continuity of life. Before weaving, planting, or birth rituals, the leaves are crushed and chewed. With the conquest, the indigenous people were abused and made addicts to the leaves so that they could be exploited for their endurance in working the mines. In this painting, Betty LaDuke shows us the image of the spirit alive in the coca leaves, which, when ingested, infuses our own spirit with vitality. The act of eating is shown in its spiritual as well as its material form, and both are depicted as essential to our sustenance.

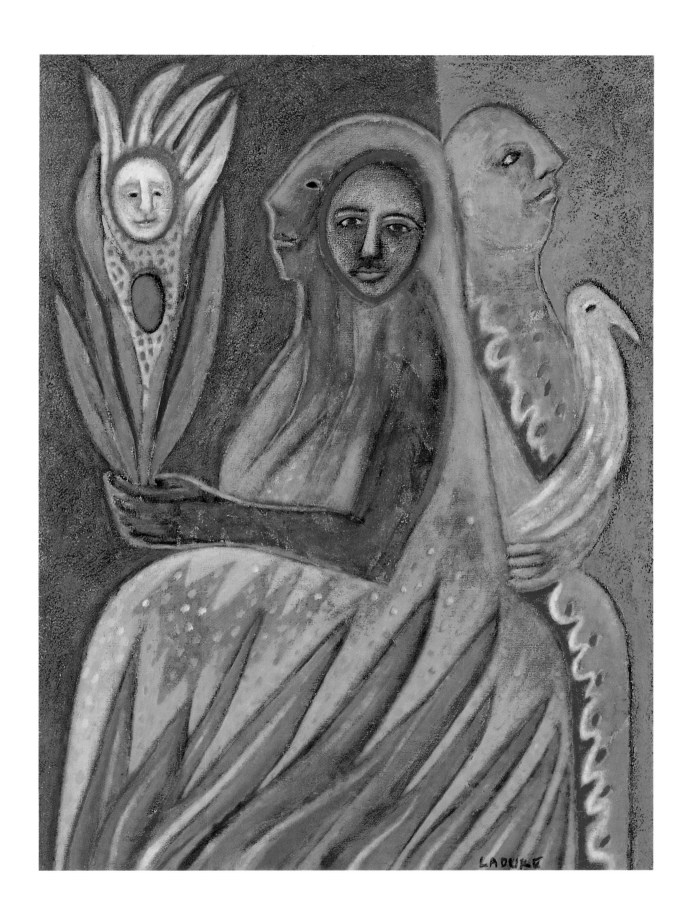

▶

Africa: Healer 1988, acrylic, 68 x 54 in.

The image of this magical, mythic mother charts a healing voyage within all people from the Earth to the sky. It reveals the powers of the moon, the sun, the stars, and the all-seeing eye. It is based upon the people the artist observed selling dried herbs and skeletal creatures in the market. This one image unites psychic healing, physical mending, male and female, and all animals and plants. The rhythm rises and mounts upward from the Earth as the energies are channeled through the healer's body, ultimately emitting energy via the hands and the crown of the head, which then merge with universal power. These energies, whose prime source is the Earth, heal the healer as well as the person seeking healing. They never leave the healer depleted or weakened. On the contrary, the healer is empowered when giving a healing.

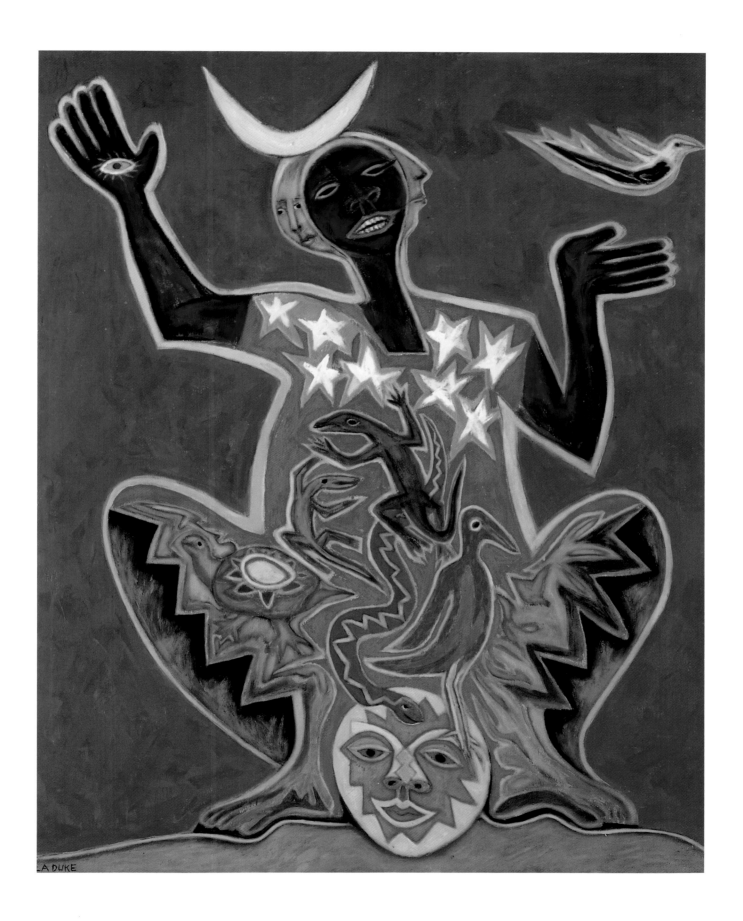

9 pilgrimages and processions

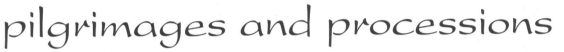

Betty LaDuke's journeys to Latin America, Africa, and Asia can be best understood when compared to sacred pilgrimages made by believers to their sacred site or temple. In the West we have turned our pilgrimages to sacred sites inward, and instead of journeying to a location in exterior reality, we journey deep within via psychotherapy to the places of pain and trauma in which we have lived. The advantage of the pilgrimages and processions made collectively and on foot by people in primal cultures is that the group or tribe becomes a collective witness to the miracles that occur on the way. The events can be shared by all, and there can be no disputing the veracity of magical phenomena. Whereas in the West people who report having observed such phenomena (often miracles) are incarcerated in insane asylums, in other cultures the person who experiences a miracle may be understood to be a prophet.

◀

India: Pilgrimage to the Ganges 1974, acrylic, 72 x 68 in.

The Procession to the Ganges is a sacred pilgrimage shared by an entire culture. Hindu families walk
very long distances to bathe in the sacred river's holy waters. They pray to end their lives at a sacred
site such as the Ganges River, so that eventually they can be released from the karmic cycle of rebirth.

In this world view, the river is an active, creative force. It is conceived of as a living goddess. The
women on the pilgrimage are accompanied by the cow spirit, which is invisible but very real to them,
and very sacred. Here all of nature—visible and invisible, animal, river, plant, and human—is
enlivened and blessed by the energies of the gods and goddesses alive in the universe and in the
hearts and minds of those who bear witness to their existence and their miracles.

Guatemala: Procession 1978, acrylic, 72 x 68 in.

In this painting the artist has used the cross as an important magical element. As the Christian saint
passes in the annual procession, the villagers glimpse their pre-conquest indigenous roots. Indeed, the
procession, in which they act out the drama of the conquest, permits them to see clear through the cross
and to perceive it as a mask, concealing their ancient, sacred ways. Thus, the cross becomes a
crossroad as well as a crucifix.

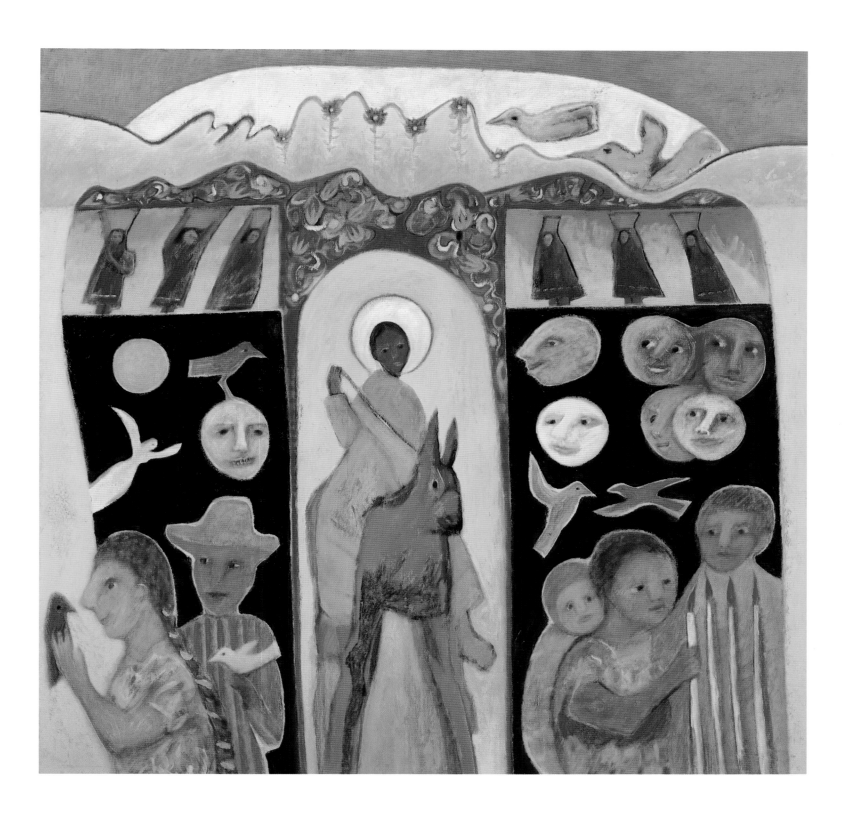

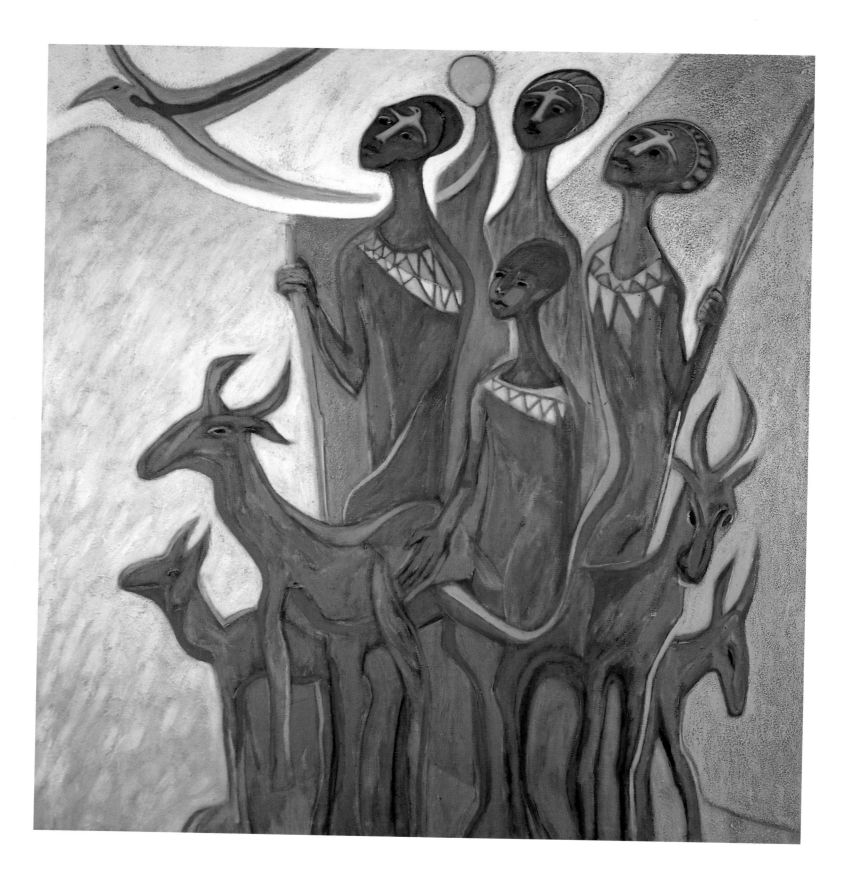

◄

Africa: Masai Spirit Quest 1988, acrylic, 72 x 68 in.

For the Masai all land is sacred and every outing is a kind of pilgrimage. These seminomadic youths have been attuned to nature since their earliest childhood. They receive messages from the birds, who inform them of what is happening elsewhere. They live in balance with the ecosystem, taking no more from the Earth than what meets their basic needs. When they hunt, they commune with the spirits of the animals. They honor them in the hunt, and thus nature gives them both material and spiritual nurturance.

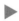

Africa: Osun's Spring Rite 1990, acrylic, 68 x 54 in.

In this procession a virgin carries a huge calabash with water on her head. She is going to the sacred shrine of Osun. If the water spills, it's a bad omen for the village. The bird with stigmata that looms over the virgin is the spirit of the calabash. All the spirits of the villagers, both human and nonhuman, are present on this pilgrimage, accompanying the virgin. LaDuke makes their presence visible to remind us that her journey is not an individual one but a collective one. All of their destinies are affected by the success of the spring rite the virgin performs.

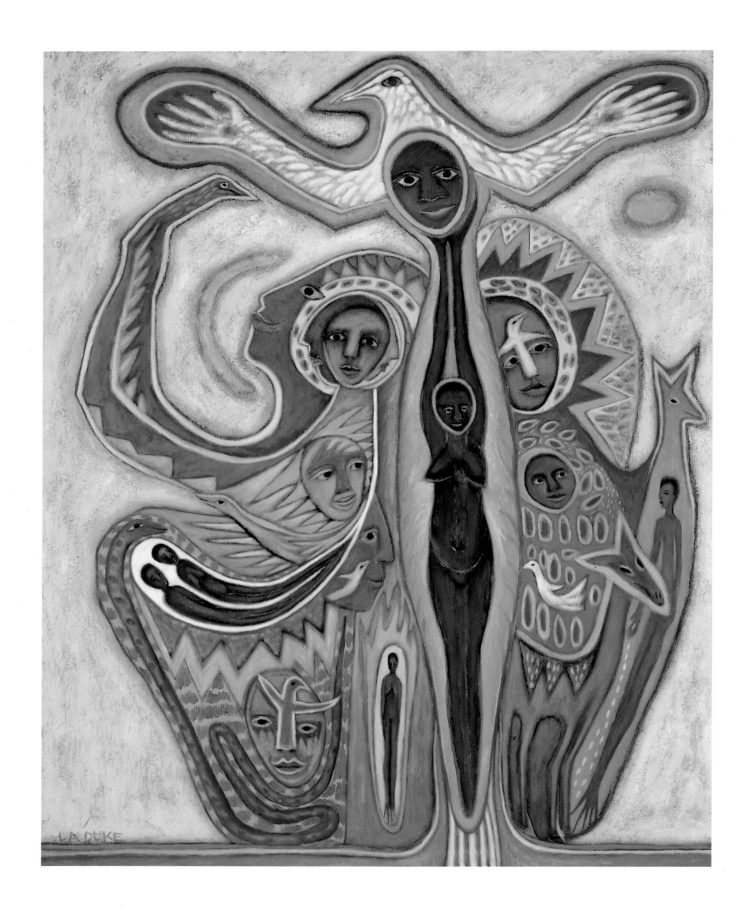

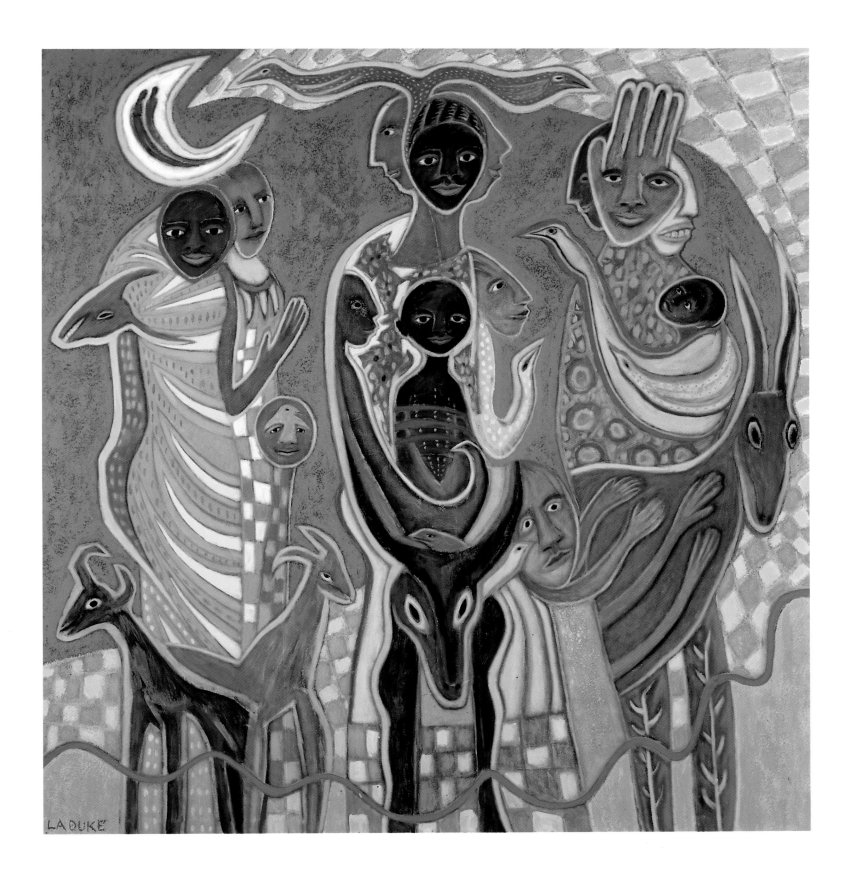

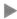

Africa: Spirit Catchers 1991, acrylic, 72 x 68 in.

These pilgrims are covered in checkered and nettled cloth because these patterns are often used on shrines to trap the evil spirits. These cloths will protect their children and their cattle from bad influences as they proceed on their sacred journey.

Africa: Osun Procession 1988, acrylic, 68 x 154 in. (diptych)

In this diptych, long processions of ordinary women carrying their children are silhouetted against the horizon as they proceed to the river to honor the fertility goddess, Osun. The women carry massive bundles of produce on their heads, which the artist has transformed into calabashes with black and white birds of sorrow and joy—sorrow because of colonial oppression, and joy because the white birds are the carriers of the dream.

The woman on the right stops and faces forward, and her fingers become birds. She is reaching out toward spirits for a change, a realization of the dreams of joy for the next generation that are carried by the community to the river goddess.

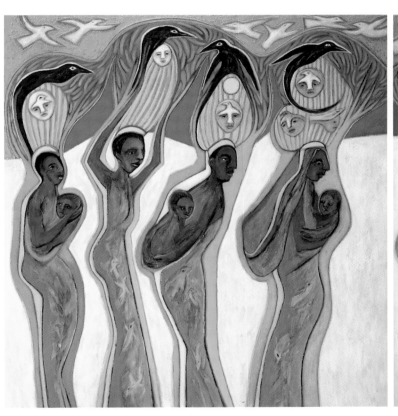
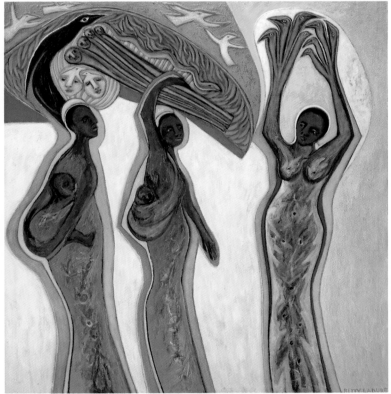

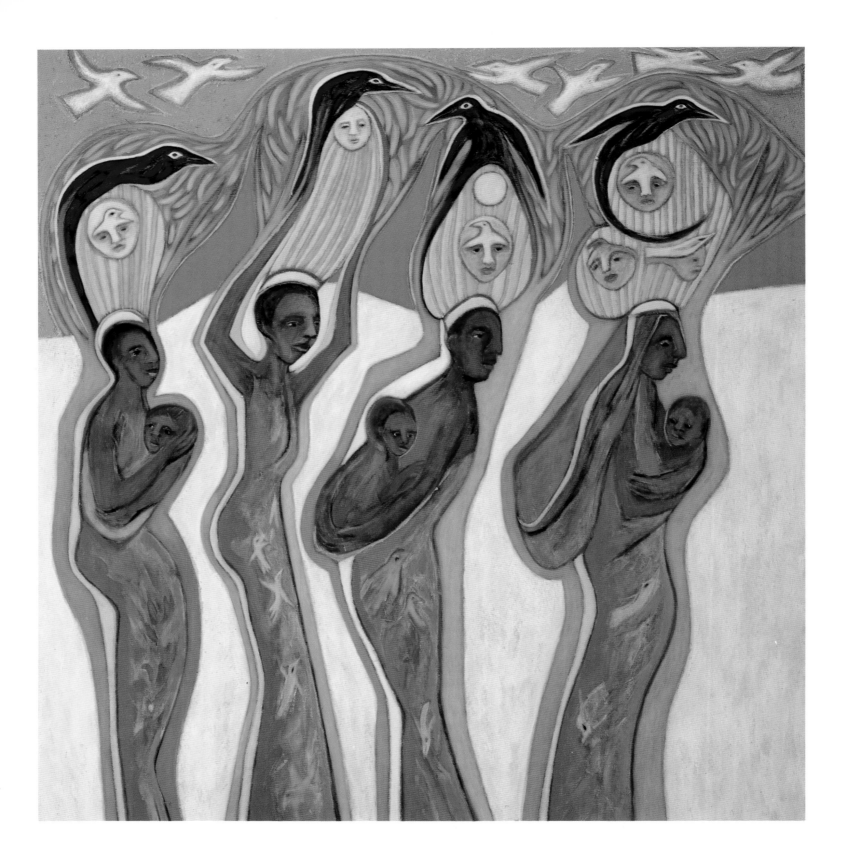

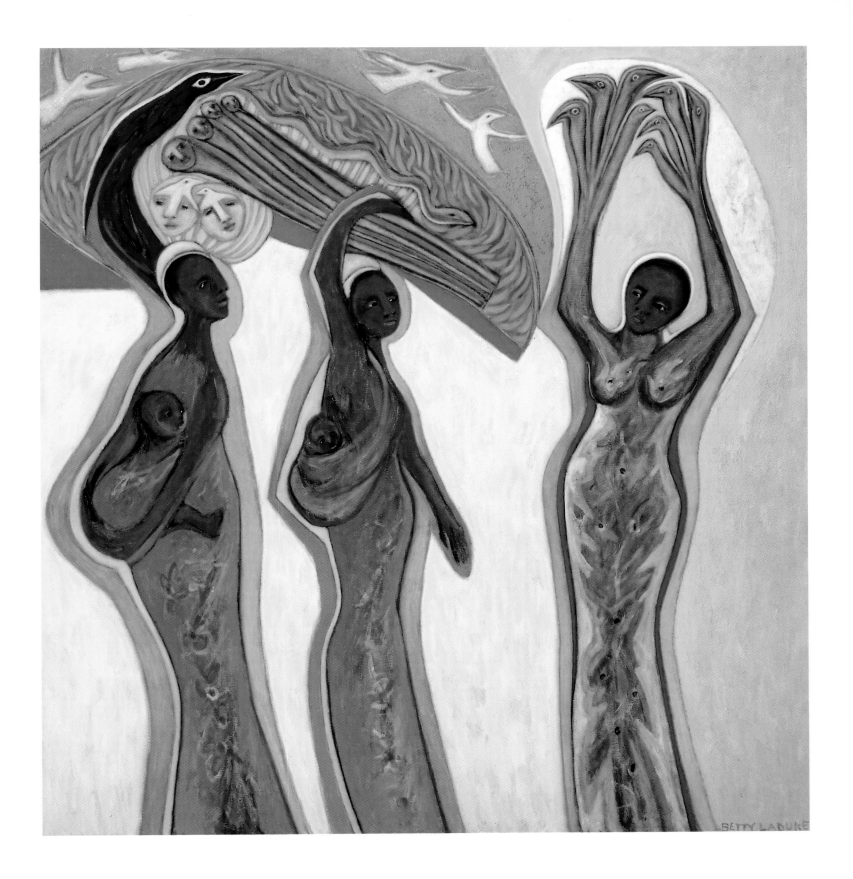

10 death and the spirit's journey

Our voyage through this book began with the *Journey Homeward*. Now we have come to understand that what we had assumed was the last leg of the trip was actually the commencement, and that what we had thought to be the end was, in fact, a new beginning. Similarly, death can be envisaged as a commencement rather than a finality. It may be the final moment of the earthly journey in material reality, but it may prove to be the beginning of the souls' further evolution beyond this world. In order to conceive of death as the beginning of the next coil on the spiral of the soul's travels from one dimension and incarnation to another, we must expand our notion of life to one that encompasses all of creation, both visible and invisible, rather than one that includes only the tangible.

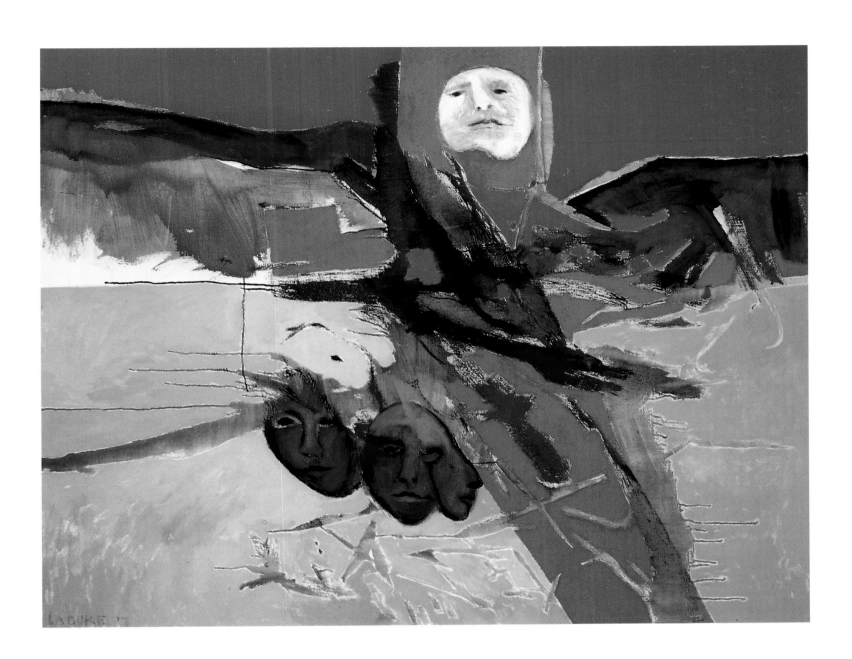

◀

India: Long Night's Journey 1973, acrylic, 44 x 32 in.

Long Night's Journey is about the Hindus' desire to die at the Ganges River so that, after cremation, their ashes will enter the current to nourish life again. When they die, they are wrapped in orange and burned on a pyre. Their ashes are thrown into the Ganges River, and their souls will be reborn according to their karma. This painting's abstract style is suggestive of the ultimate mysteries of the unknown. The deceased has taken on the aspect of an angelic figure. Through the cremation ceremony, she will join the other souls, who are already flowing in the stream of life.

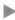

China: Memories of the Bitter Past 1979, acrylic, 68 x 54 in.

In 1976, when Betty LaDuke visited China, the people were enthusiastic about the revolutionary changes that had taken place there, and they contrasted them with their "memories of the bitter past" under a system of warlords and feudal oppression.

Here the red sun and the white light are entering the collective body of memories to cleanse and burn away the bitterness that has left traces in the spirits and the memories of the people. The sun and the light symbolize hope for the future, when the darkness will have been fully turned to light.

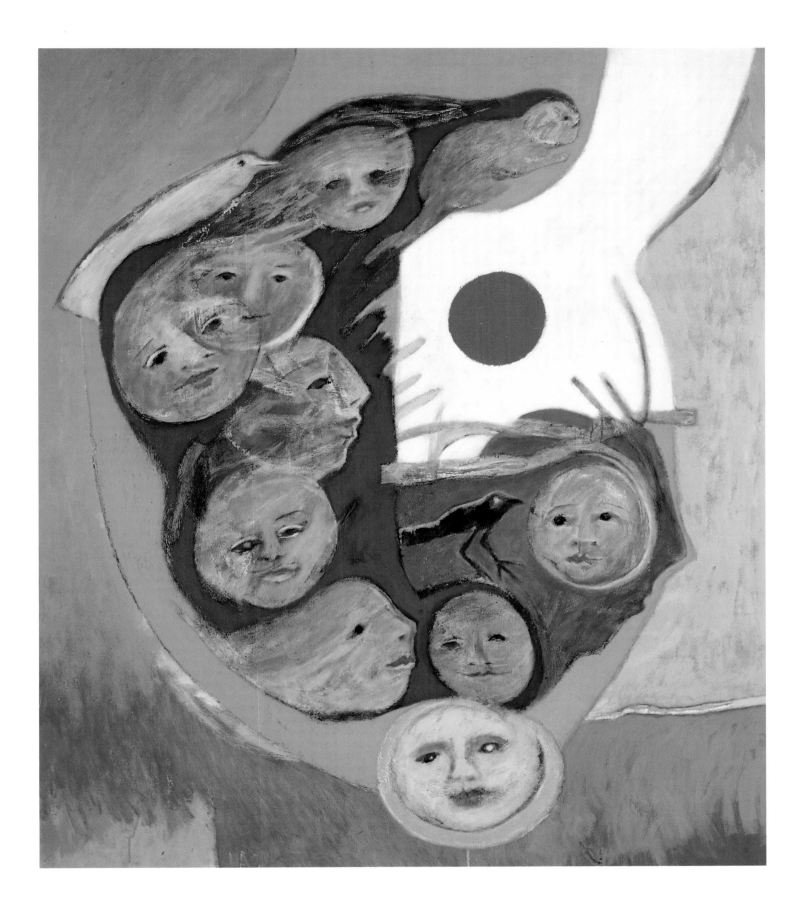

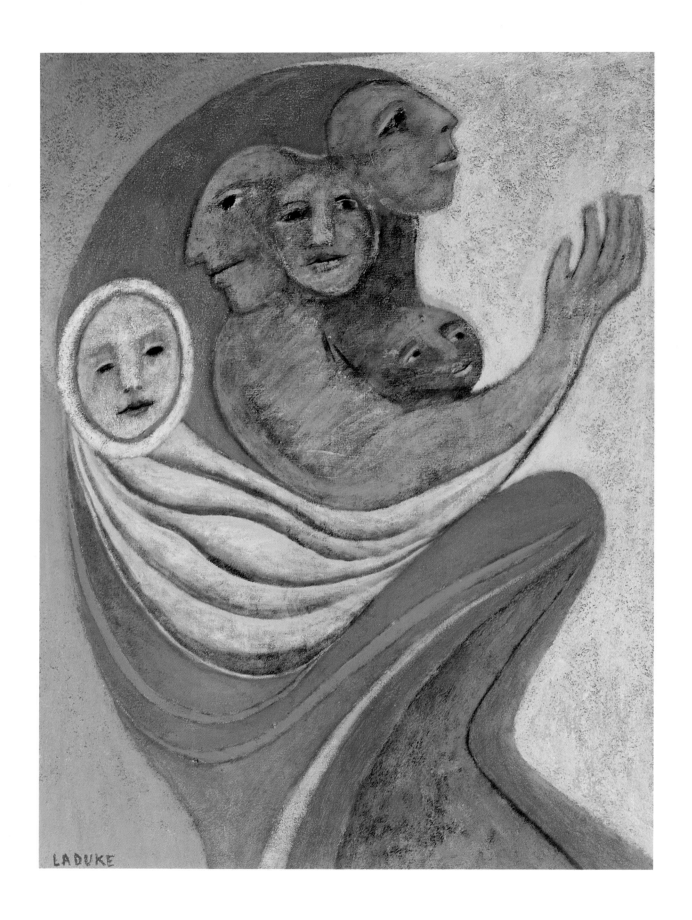

LADUKE

◀

Bolivia: Pachamama and the Spirit Children 1984, acrylic, 44 x 32 in.

Here the souls of the children who died in the first months of life are gathered together in the embrace
of Pachamama. The Great Mother always remembers her little angels. Their souls go on to further
evolution in realms beyond the material plane.

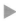

Bolivia: Pachamama and El Tio 1984, acrylic, 44 x 32 in.

While mourning her dead child, a Bolivian mother will pray for a new life to stir within her through the
assistance of the magic coca leaves. El Tio, the large head on the right, symbolizes prosperity and
good fortune. El Tio is like a Santa Claus that one prays to so that the good things in his pack might
spill into one's own life. To the left is the healer with the magic coca leaves. The woman carrying El
Tio's head is offering horned branches to the spirit world. She has become a tree of life. Belief in the
constant reflowering of the tree of life means that death will always be followed by new life, and that
the generations to come will continue to honor the heritage of Pachamama.

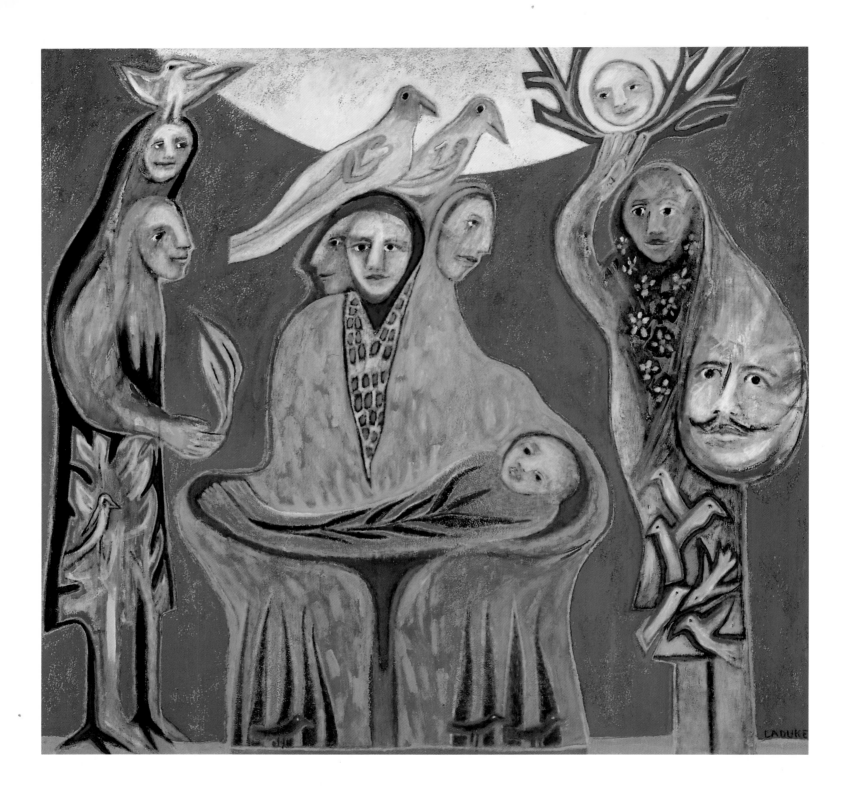

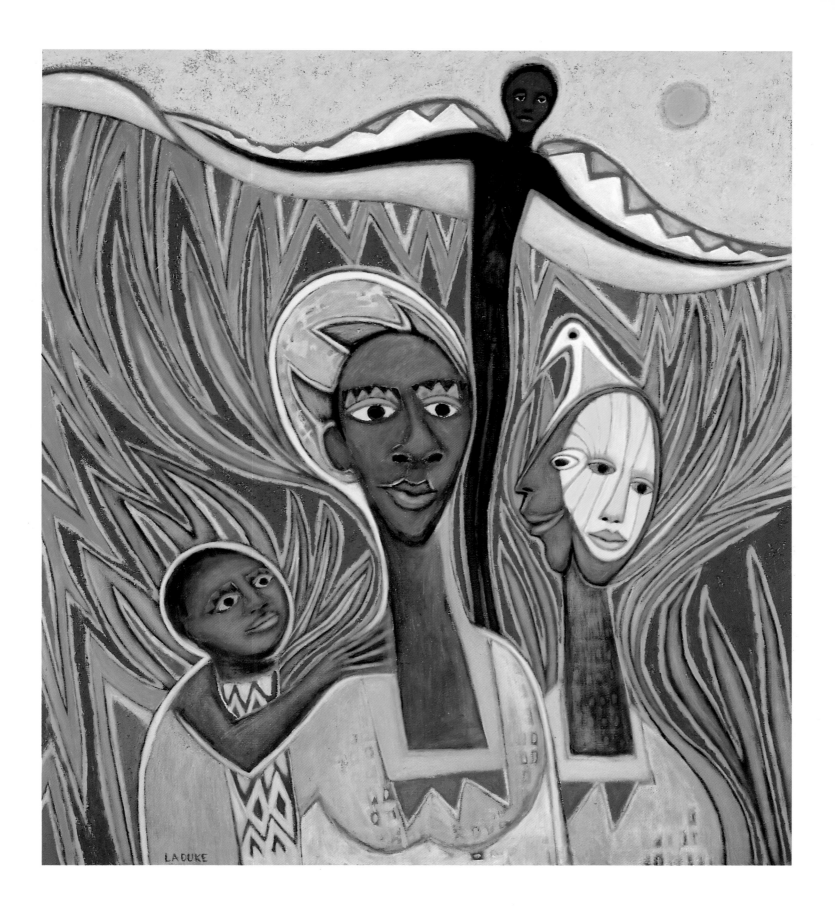

◀

Africa: Mourning, Homage to the Victims of Apartheid, Colonialism, and Oppression 1992, acrylic, 48 x 54 in.

The homage to and the mourning for those whose lives were lost in the political struggles for freedom mark important stages in the spirit's journey toward liberation. The presence of all those attending the services for the dead enables the spirits of the deceased to cross over, to journey to the source of light, and to find another form of liberation, a spiritual form.

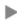

Jamaica: Tomorrow (Homage to Edna Manley) 1985, acrylic, 68 x 54 in.

The last painting reproduced in this book, which represents the pilgrimage made by Betty LaDuke to her own sacred sites of spiritual nurturance and rebirth, is entitled *Tomorrow* and pays homage to Edna Manley. Manley was both a powerful sculptor and a political activist. She was a white woman, originally from England, who lived as a sculptor and activist in Jamaica. Her entire artistic oeuvre was devoted to portraying the struggle of the Jamaican people to liberate themselves from colonialism and to retain their pride and dignity as a very rich culture, part of the African Diaspora.

When Betty LaDuke visited her in 1980, Manley told her, "One must always look forward to the future with hope." This painting is one of hope that through the commingling of the spiritual and the physical, and via procreation, artistic creation, and the belief in rebirth via cosmic and spiritual creation, there *will* be a bright tomorrow.

This book closes by sending off birds of peace, spirits of hope, into the universe. These spirits are your thoughts and your visions as you come away from these images inspired by the spirit of political and spiritual knowledge that art can bring about a multi-cultural rebirth and a planetary healing in our time.